9/12/07

SURREALISM

The Dream of Revolution

R I C H A R D L E S L I E

NEW LINE BOOKS

To Amy for her friendship and support.

Copyright © MMVI by New Line Books Limited

Fax: (888) 719-7723
e-mail: info@newlinebooks.com

Printed and bound in Singapore

ISBN 1-59764-100-6

Visit us on the web!
www.newlinebooks.com

Author: Richard Leslie

Publisher: Robert M. Tod
Editorial Director: Elizabeth Loonan
Book Designer: Mark Weinberg
Senior Editor: Cynthia Sternau
Project Editor: Ann Kirby
Photo Editor: Edward Douglas
Picture Reseachers: Heather Weigel, Laura Wyss
Production Coordinator: Annie Kaufmann
Desktop Associate: Paul Kachur
Typesetting: Command-O

Picture Credits

CONTENTS

INTRODUCTION

Surrealism officially emerged as a movement in art, although not necessarily a movement in the visual arts, with the 1924 publication of a manifesto by the French poet André Breton. Breton's sensibilities, like those of Surrealism in general, were sharply defined by the broad and preceding development of ideas in the European art world.

But Surrealism embodied a contradiction. Like the avant-garde, their dream of revolution was a radical break from the past into something new. At the same time, they argued that their moment of "revolution" was heralded by history—if one selected the right history! Surrealism was to be the heir of a new, modern spirit at the same time that it was also an historical accretion, slowly emerging from broader, older streams of human creativity. The broad tapestry provided individual threads to be rewoven—from the naturalism of the Italian Renaissance to the ideas of the major avant-garde movements such as Cubism, Expressionism, Futurism, Metaphysical art, and Dadaism. So important are these multiple fibers that the first two chapters of this book are given to them.

The central shaping force was the energy of the nascent century, the feeling embodied in the coming of electricity,

the airplane, and the motorcar. Nowhere was this more apparent than in the First World War, a conflagration that began on horseback and ended with tanks. The Second World War served as a bracket to energies that defined the European avant-garde before, during, and after the Surrealists.

One thread begins, ironically, with Pablo Picasso and the Cubists in Paris. Little could seem further from the rebellions of the Surrealists than this art, with its clean, almost machinelike edges of flat "cubes." But not only was Picasso Breton's favorite artist, Cubism was also the origin of a basic pictorial language and attitude for the avant-garde of the new century. The techniques developed by Cubism during the years 1912 to 1914—such as the use of collage and the inclusion of found objects— were applied by many artists and movements throughout Europe to ends quite different than the Cubists had envisioned. Nowhere was this more true than among the German Expressionists, many of whom became members of the Dada movement after 1916. By 1919, collage in the hands of an artist like Max Ernst was considered to be proto-Surrealist. Thus Surrealism drew upon the earlier elements in Cubism and Expressionism. And there

Two Children Are Threatened by a Nightingale

MAX ERNST; *1924; oil on wood with wood construction; 27 x 22 x 4 in. (69.8 x 57.1 x 11.5 cm). The Museum of Modern Art, New York.* A Surrealist work by Ernst shows elements of Expressionism, Metaphysical art, Dadaism, collage, construction, and psychology in a unique synthesis.

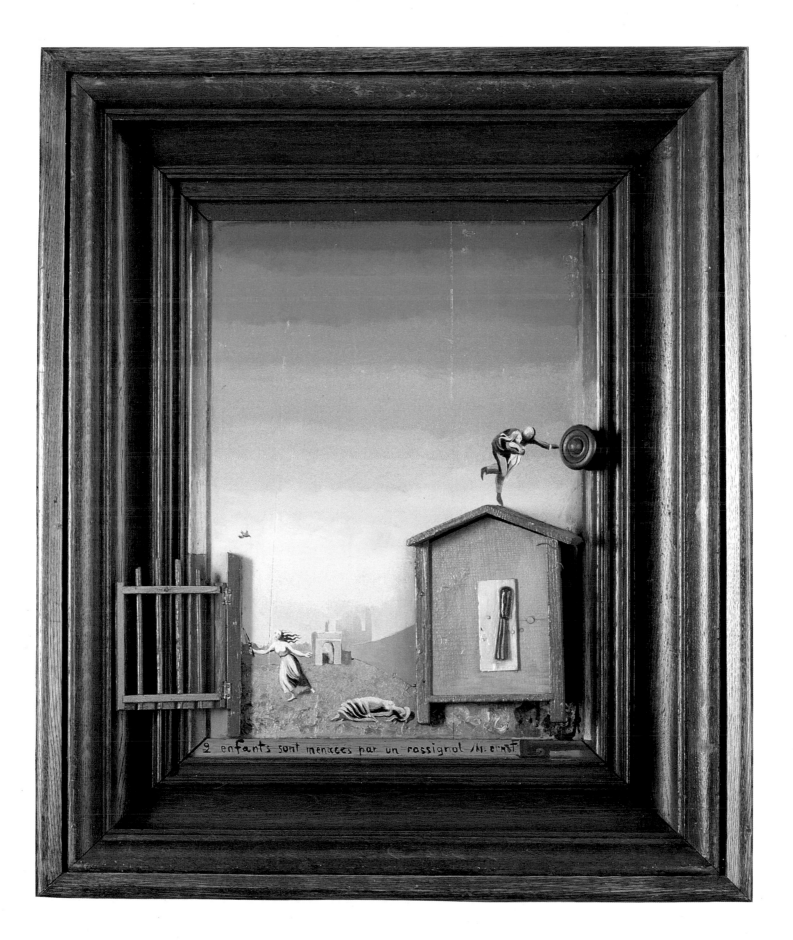

2 enfants sont menacés par un rossignol /M. ernst

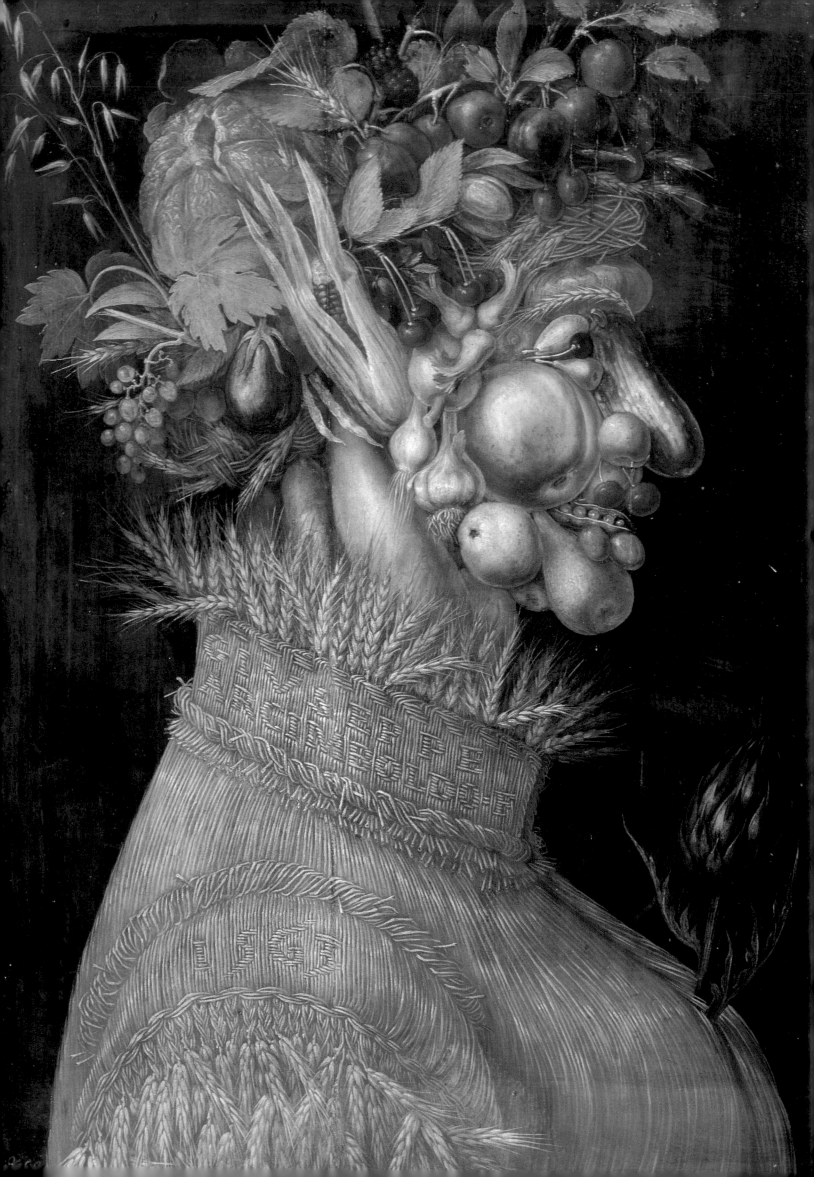

FOLLOWING PAGE:
Garden of Earthly Delights

HIERONYMUS BOSCH; *detail; c. 1505;*

oil on wood; right panel, Hell. *Prado, Madrid.*

Bosch appears on André Breton's list of historical
artists whose freshness of vision allowed ours
to be refreshed and restored to its "primitive" state.

were other sources.

The young hellions of the Italian Futurist movement began in 1909 to develop an art and philosophy of energy and dynamism to force their classically laden past to merge with the future of a speeding automobile. Much of the nihilism and many of the tactics they developed were picked up several years later by the Dadaists, whose cabaret's drums and performances beat steadily against, or perhaps in tune with, the drums of war.

By 1919, André Breton and his group of French poets were direct heirs to Dadaist ideas that had developed across Europe and were beginning to congeal in Paris. By 1922, they began to break away from the Dadaists to form a less negative program. Breton, especially, turned to the ideas of Sigmund Freud to establish a psychoanalytic foundation for the Surrealist dream of revolution. Two years later, Breton published the "First Surrealist Manifesto." Within one year the Surrealists mounted their first exhibition of visual art in Paris, and by 1926 they opened their own art gallery. In 1929 dissension in the Surrealist ranks broke into an open schism against Breton's authoritarian leadership and political alignment with the French Communist Party. This period of crisis in the movement opened a second branch of Surrealism associated with the more radicalized ideas of Georges Bataille. Ironically, new members arrived in the early 1930s, and the movement became known worldwide with a series of international exhibitions that lasted into the 1950s.

By 1939, with Franco's Fascist victory in Spain, the Russo-German pact, and the beginning of World War II, the Surrealists, already international in membership and orientation, spread away from the Continent. Many arrived in the United States by 1941 and their presence profoundly affected the development of art in New York. By the end of World War II, the Americans had accumulated sufficient information from the Europeans to begin their own synthesis of ideas, culminating in Abstract Expressionism. But the impact of Surrealist ideas did not end there.

Many of the Surrealists continued to work into the 1950s and '60s, and they provided a focus to two more generations of artists. Young Americans, such as Robert Rauschenberg and Jasper Johns, exhibited with them in the 1950s. Other artists in the late 1950s and '60s involved in Happenings and the beginnings of performance art felt the shaping force of the Surrealists. Assemblage artists, such as Lee Bontecou, and those using organic shapes and psychological motifs, like Louise Bourgeois, owed much of their aesthetic to the first systematic explorations of the psyche employed by Surrealism.

A book on Surrealism also becomes a book addressed to the avant-garde spirit, a span of time and ideas which forms a large part of the most stimulating art and ideas in the twentieth century. It was a period of great promise, a utopia, where they dreamed the dream of revolution.

Summer

GIUSEPPE ARCIMBOLDO; *1656; oil on limewood; 29 x 20 in. (76 x 50.8 cm). Kunsthistorisches Museum, Vienna.*

Arcimboldo (1537–93), a Renaissance artist from Milan and court painter to the Hapsburg kings in Prague, created symbolic figures through visual puns. Salvador Dalí sought inspiration from their much-imitated transformations.

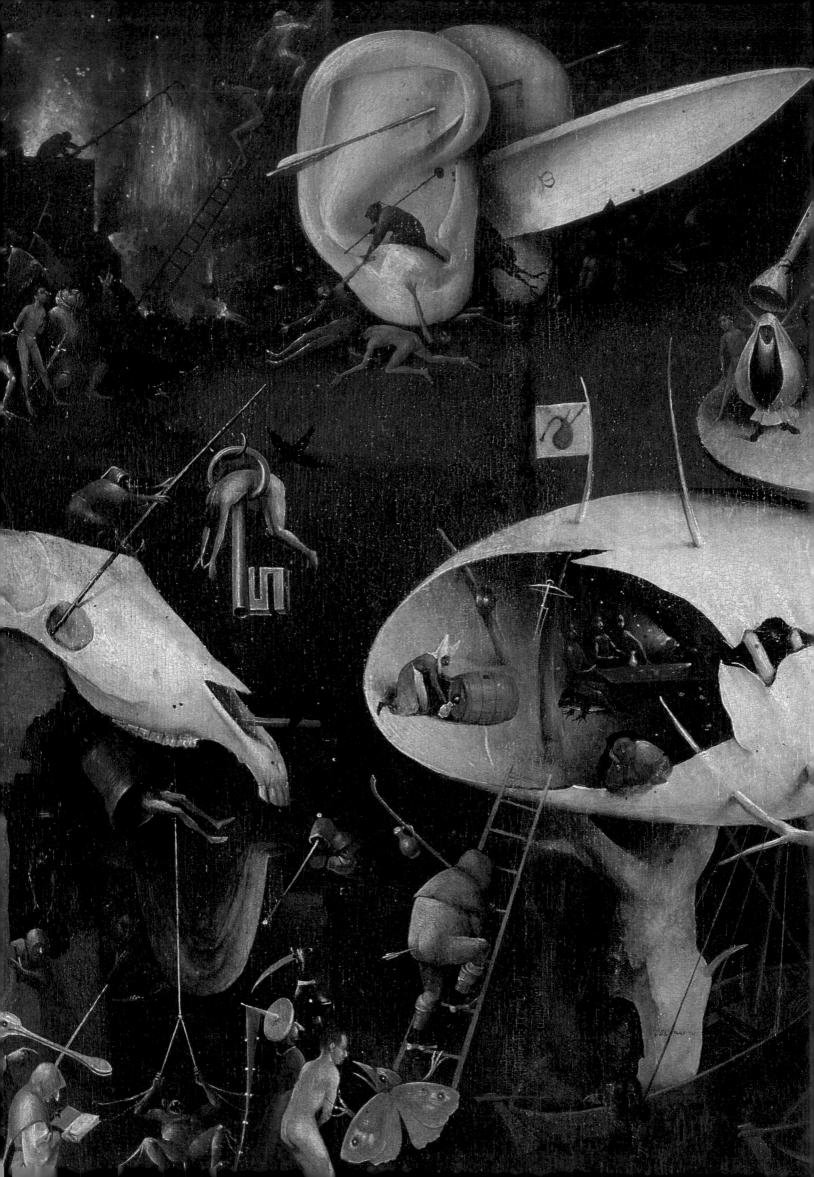

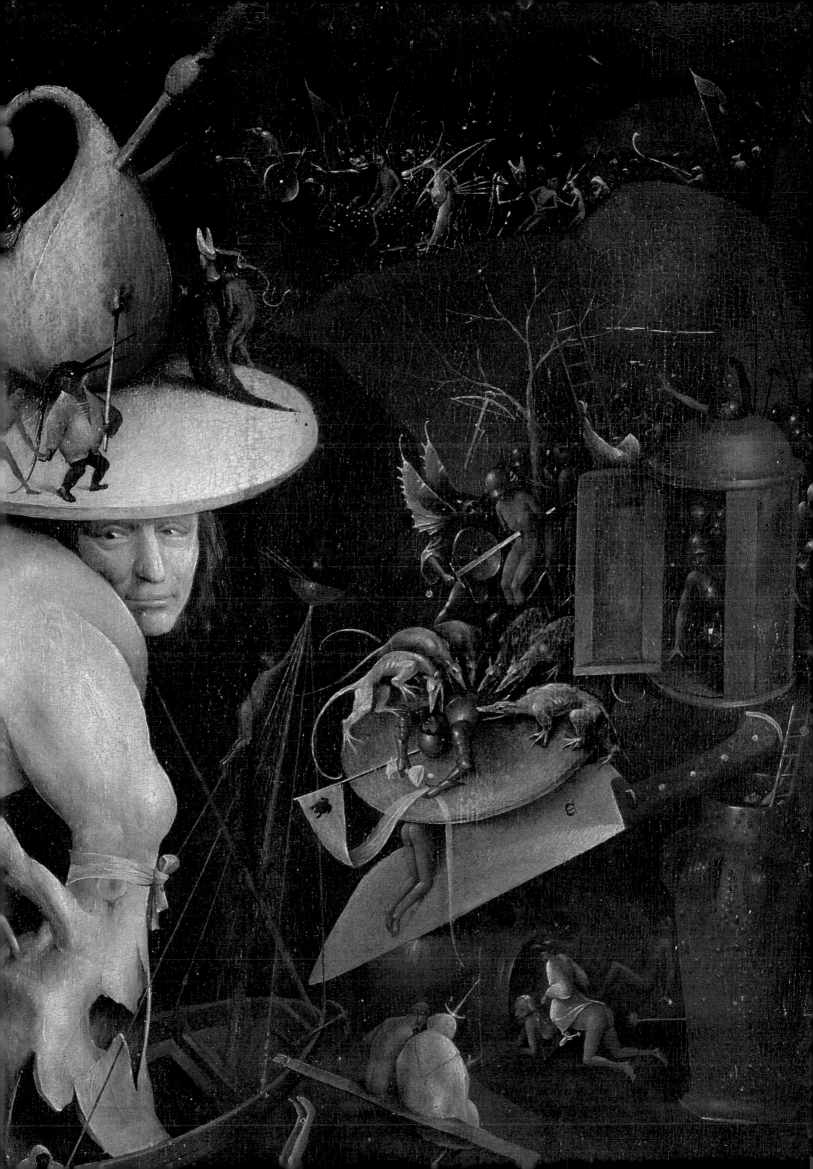

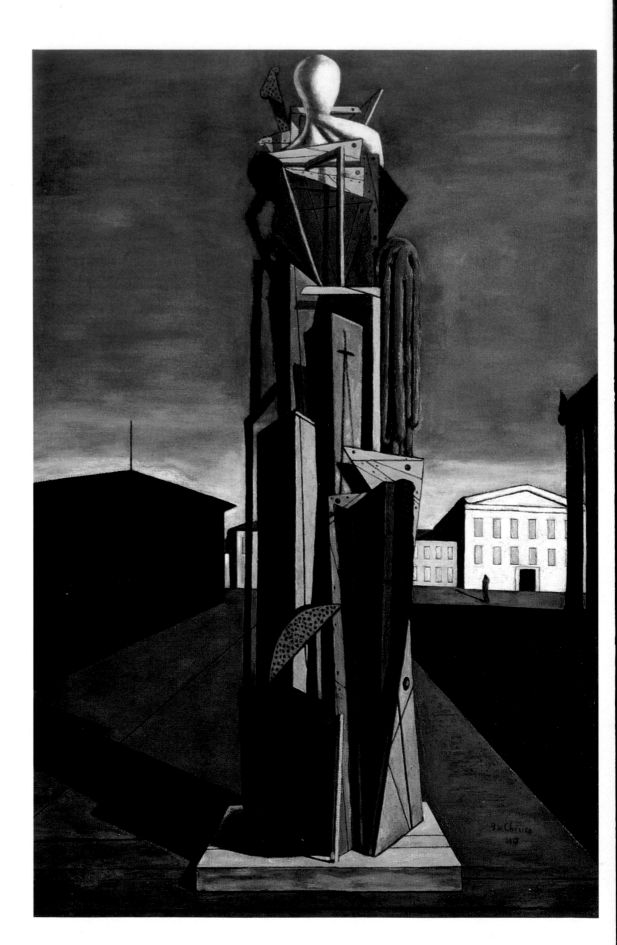

The Great
Metaphysician

GIORGIO DE CHIRICO; 1917;
*oil on canvas; 37¾ x 27 in.
(104.5 x 69.8 cm.). The Philip L.
Goodwin Collection, The Museum
of Modern Art, New York.*
De Chirico added tailor's
dummies to his immobile
spaces and unexpected
perspectives, to represent
the human element which
he wanted to imply
but not to allow. This
sense of presence through
absence greatly appealed
to the Surrealists.

BEFORE SURREALISM THERE WAS...

Surrealism aimed to revolutionize life through art. It succeeded in revolutionizing the history of modern art by opening new doors of perception, but this was neither a simple nor a linear development.

The general histories we have come to accept as the pathways of the radically new in the history of modern art were generally rejected by the Surrealists as irrelevant if not downright stupid. They countered with a different construction of history from selections bounded by their particular desires. To study those histories and selections is to learn a great deal about the nature of Surrealism.

The New History

In the late nineteenth century, young radicals in the visual arts across Europe agitated for their art and ideas as direct descendants from the early part of the century. In Paris, they wrote a new history that ran from the broken brushwork, "modern" subject matter, and brightened outdoor colors of the painter Éugene Delacroix, through the experiments in light and atmosphere of Impressionists like Claude Monet in the 1870s and '80s, to arrive at their own Post-Impressionist easels and Symbolist ideas. They constructed a new and progressively "modern" historical lineage outside the approved channels of recognition and support, government-sponsored salons, and academies of art. This was the avant-garde art, and it is this history that is widely accepted today as the origin of modern art.

In the early twentieth century, artists and commentators alike recognized that their concerns and styles were directly related to this line of avant-garde art. The now "scientifically" systematized colors and compositions of Georges Seurat's quiet scenes were said to correct the lack of structure in Impressionism while maintaining its bright palette and concerns for outdoor effects. Paul Cézanne's structural slabs of paint also were proclaimed to lead out of the lessons of Impressionism through a revitalized concern for surface structure, and into the Cubism of Pablo Picasso and Georges Braque. Concurrently, the lessons learned from the Impressionists led Vincent Van Gogh and Paul Gauguin through a revitalized concern for expression and a symbolism located less in subject matter and more in the newly modern language of colors and lines.

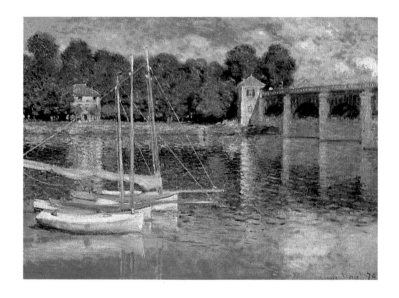

Bridge at Argenteuil

CLAUDE MONET; *1874; oil on canvas; 23⅝ x 31 in. (60 x 80 cm). Louvre, Paris*
Styles which were part of the new, modern tradition, like Impressionism, were considered backward by the Surrealists. Monet's pursuit of light and atmosphere radicalized art away from the academies, but Surrealists considered it an art reduced to merely retinal or "optical" exercises.

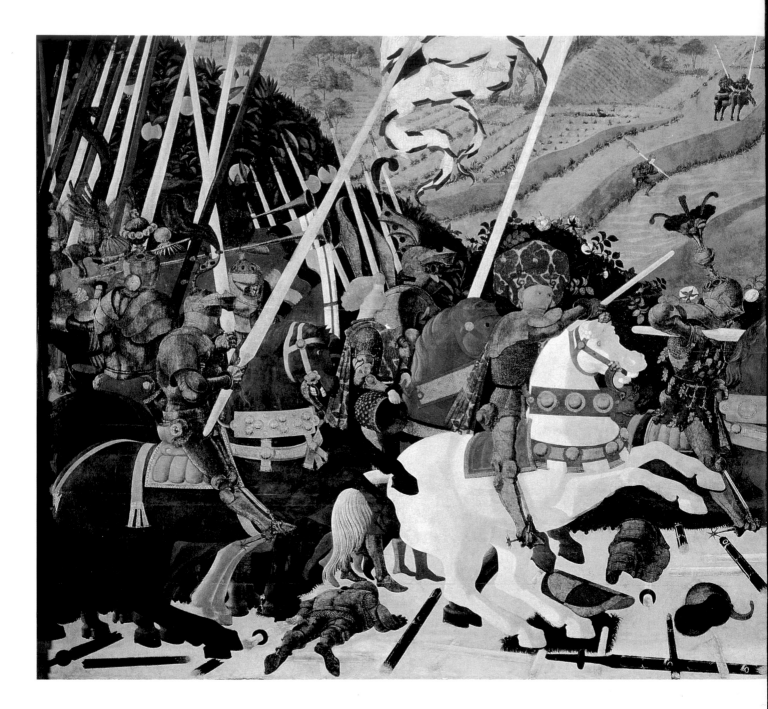

The two accepted roots of twentieth-century art—structure and expression—were formed with a newly modern pedigree accepted by today's "academy of the new." But to understand Surrealism is to know there neither was nor is a single history of modern art or the avant-garde. The Surrealists chose from a far less restricted understanding of art, and rejected or rewrote much of what was to be "modern" within their own history of modernism.

The New Old History

On one hand, André Breton considered labels such as "Cubism"—and even "Surrealism"—too restrictive to encompass the true powers of creativity: To worry "whether X or Y succeeds in passing himself off as a surrealist, are matters for grocers' assistants." Art history was for clerks; Surrealism was beyond that. On the other hand, Breton spent great energy clerking—by claiming, proclaiming, and eliminating various artists from the lists of Surrealism.

The Battle of San Romano

PAULO UCCELLO; *c. 1455; tempera and silver foil on wood panel;*
6 ft. x 10 ft. 5¾ in. (1.8 x 3.2 m). National Gallery, London.
Uccello (1392–1475), an Italian painter of the early
Renaissance, was the only historical figure mentioned
in the first Surrealist Manifesto of 1924. Like Bosch,
he was admired because he was obsessed by a particular
vision which used—but perverted—"normal" vision.

preoccupied with geometry and elements of the newly
invented linear perspective, to a degree recognized in his
own time as excessive. His three versions of a battle scene
show the lances Breton mentioned, but it is not the clash
of armies Breton's words were meant to evoke. Rather,
the Surrealists saw the battle as being between the real
and the unreal, for Uccello's excessive use of a technique
applied to the natural world gave an unnatural look to
his figures. In this way, Uccello was part of the Surrealists'
history, just as excess was considered surrealist wherever
and whenever it existed.

The Surrealists used the same criteria to sift through the
immediate past of art. Where they rejected Seurat's art as
an advance in the scientific study of optics, they admired
the "magic" and confusion of his lighting, which gave
"disturbing" effects. Gauguin may have developed deco-
rative flat colors that affected Henri Matisse, but this was
art history of no interest. It was Gaugin's attempts at
primitive innocence and reimpowering myths that the
Surrealists felt brought him close to their own aims.
Seurat and Gauguin were accepted as part of modern art
but rewritten as a new history, equivalent to poets like
Arthur Rimbaud and the Count of Lautréamont, who at-
tacked the world of appearance.

The Problem of the Visual

The roll call of visual artists active in the Surrealist move-
ment is a list of many of the most visually powerful and
disturbing creators in the twentieth century. So it comes
as a surprise and even a problem that Breton and the
Surrealist poets were, at first, not at ease with the issue of
visual arts or many of its ideas in Surrealism. It was a
movement begun by poets within literature; there were
no illustrations in their first, transitional journal,
Littérature. In his first manifesto in 1924, Breton makes
exceedingly limited reference to the visual arts, except in

Breton was convinced that the issues Surrealism ad-
dressed were age-old. He asked in 1928, "Am I to believe
then that everything began with myself? There were so
many others, heedful of the clash of gold lances under a
black sky—but where are Uccello's *Battles*? And what is
left of them for us?" Uccello serves as a good example to
demonstrate both the historical perspective of Surrealism
and the idiosyncrasies of its approach.

Paolo Uccello (1397–1475) was a Renaissance artist

Garden of Earthly Delights

HIERONYMOUS BOSCH; *c. 1505;*
oil on wood; triptych: left panel,
Garden of Eden; *center panel,*
The World Before the Flood;
right panel, Hell; *side panels*
86 x 36 in. (218.5 x 91.5 cm.),
center panel 86 x 76 in.
(218.5 x 195 cm). Prado, Madrid.
Bosch (c. 1450–1516) was a
unique individual whose
Garden of Earthly Delights
represents, to the modern
mind, the fantastic in
Western painting. The
Surrealists emphasized his
dislocations because they
occurred within normal
Christian traditions.

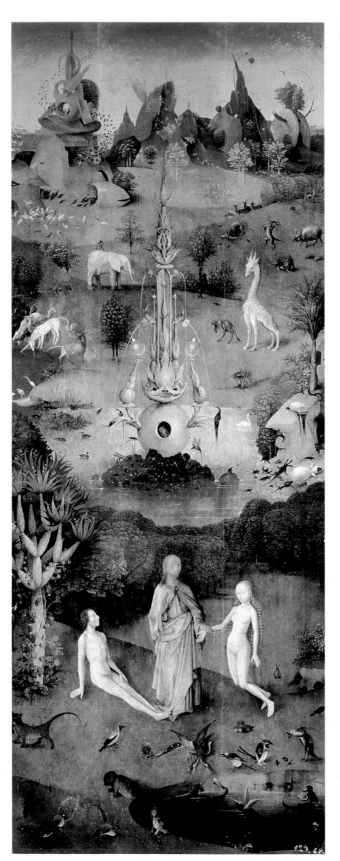

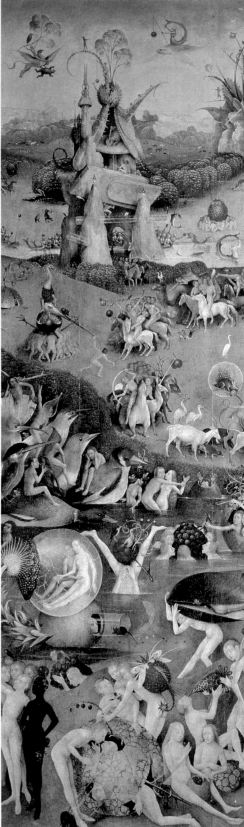

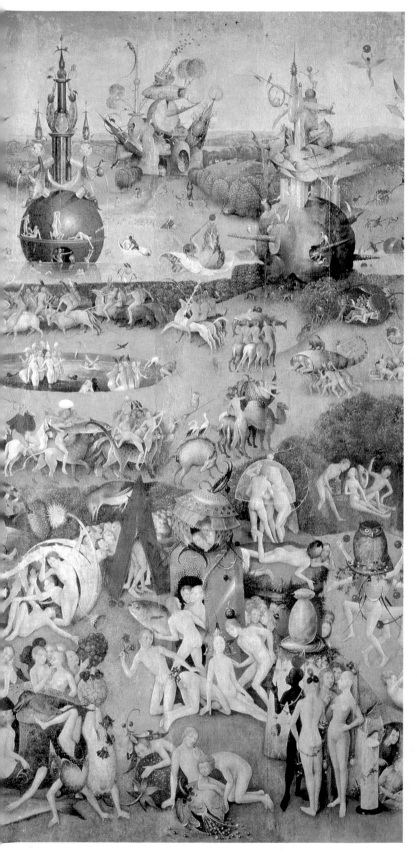

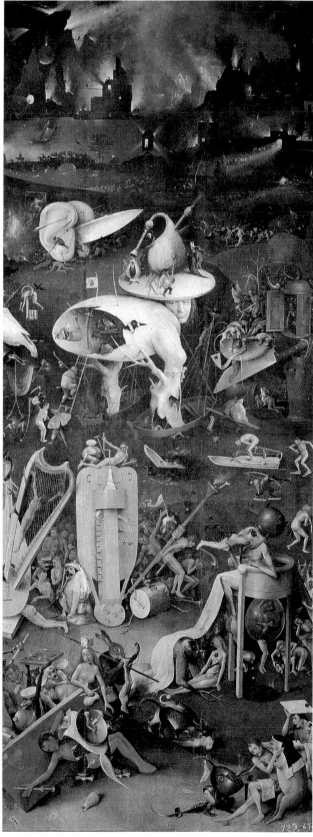

one place. To a list of writers, all of whom he calls Surrealist for one or another reasons, he attached a footnote as if an afterthought:

I could say the same of a number of philosophers and painters, including, among the latter, Uccello, from painters of the past, and, in the modern era, Seurat, Gustave Moreau, Matisse (in "La Musique," for example), Derain, Picasso (by far the most pure), Braque, Duchamp, Picabia, Chirico (so admirable for so long), Klee, Man Ray, Max Ernst, and, one so close to us, André Masson.

Art is Not the Issue

As late as 1953 Breton restated the case that everyone who argued for an "aesthetic" component for Surrealism placed its history "in a false light." For Breton, anyone concerned with "art" was bound to be misguided. Art took you into illusion and away from the "real." Surrealism had been born into a relation to language, but it was a search for the "prime matter" of language. This search led to the regions of the human unconscious where desires arose unbidden and unconstrained. This was the proper domain for art in a new understanding, and anything accepted as "art" needed to lead to the "real" by way of this path.

Those visual artists who had felt such a compulsion—and compulsion is the key concept here—and given it concrete form throughout history were admitted to the Surrealist pantheon. Surrealism constructed their "modern" history from those driven by compulsion, not from those who used colors and lines in innovative ways. As late as their 1947 international group exhibition, they planned to present from history several such "Surrealists despite themselves" alongside their own work, such as the Renaissance painter Giuseppe Arcimboldo, famous for his grotesque figures composed from fruits, vegetables, and animals.

Another such artist is Hieronymus Bosch (c. 1450–1516), whose strange vision and grotesque sense of fantasy has long appealed to modern audiences. Despite his devout religious beliefs and otherwise normal life, Bosch's vision existed outside the main line of development for the rest of the Low Countries in the fifteenth and sixteenth centuries. Even his painted themes are normal, most based on the life of Christ. But it is in the marginalia that his imagination created a world of demons, half-animal, half-human creatures doing fantastic things set within imaginary landscape and architecture.

Bosch's superbly realistic painting style rendered images that fit Breton's criteria of clarity and concreteness but they also were part of a history Breton saw of a primitive vision made manifest, one which included a number of naturalistic artists. Bosch as an artist was able to impose simultaneously the reality of his images on the beholder while also altering normal relationships to the images. By means of images he created the real, but the real now included, by necessity, the unreal.

Rethinking the Visual

Breton expressed his opinion about Bosch in the 1928 essay "Surrealism and Painting," in which the poet wanted to do for visual language what he had done for poetic language in 1924—call visual art to task, disclose its real goals, and outline those who had done so in the past, like Bosch, or in the present, like Picasso. The central argument Breton used was an important and widely shared one for Surrealists.

The visual arts are based on the most powerful of physical faculties. It is vision that allows us control over the world, and the Surrealists took it seriously because they valued reality, or their own definition of it. Breton recognized that a "few lines" and "blobs of color" could give immediate power. The formal elements of painting lent a power to painted objects that compelled us to move into the illusion of the world represented. This happens through all visual art and the subject does not matter. We could therefore conclude that any work that so transported us would do. But the Surrealists wanted something more specific, and not all works either called to them or answered their call. Visual art must give a sense of following an internal vision or model more than an external one, yet never abandon one for the other.

The Apparition (Dance of Salome)

GUSTAVE MOREAU; 1876; oil on canvas; 41¾ x 28⅜ in. (106 x 72 cm). Louvre, Paris.
Moreau (1826–98) was a French Academic painter who explored ancient cultures and mythologies, but in a style and with images at odds with most Academic work. Breton praised him all his life; others argued that he was merely a lenient teacher, and too much a painter of literary ideas.

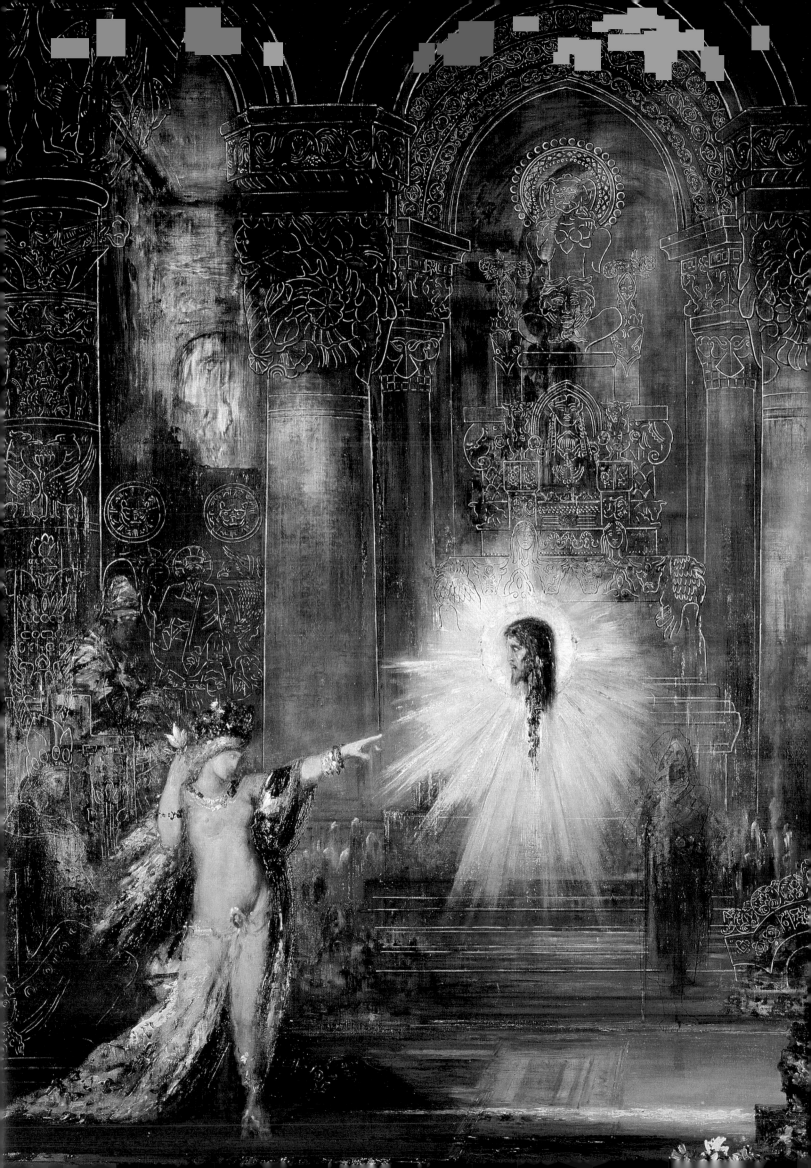

This makes a great deal of Surrealist writing about the nature of art confusing, especially with its insistence on reality. The Surrealists wrote a variation on the theme of "I-know-it-when-I-see-it" but purposefully avoided prescribing a formula for its accomplishment. It was a revision of reality, one which moved to include what had been excluded, what was "invisible" to the normal, conscious eye. It was a different vision—the ability to see a primitive world—that they desired. In a sense, they were opposed to vision, but only as it had been used merely as an organ of perception.

The Savage Eye

Breton opened his major defense of the visual arts, "Surrealism and Painting," with the assertion: "The eye exists in its savage state." The only possible witness to the

The Island of the Dead

ARNOLD BOECKLIN; *1880; oil on wood; 2 ft. 5 in. x 4 ft. (73.6 x 121.9 cm).*
Reisinger Fund, 1926, The Metropolitan Museum of Art, New York.
Famous for his moody landscapes peopled by mythological and symbolic figures, this Swiss painter is mostly absent from Breton's lists, although admired by others.

"marvels" of the world is the "wild eye." But this eye could not be inscribed within any one arena or category. It existed in academic painting as well as in the avant-garde; in some but not all fantasy art; most certainly in art from "primitive" cultures; in the art of those considered to be untrained; and especially in those psychologically displaced from the mainstream of society. But perhaps the greatest challenge was to locate it in those working in the world at the moment and to develop it within themselves. In either case Breton possessed a secular-made-holy priestly power to select, bless, and excommunicate those moments, artists, and works.

When Breton was sixteen he visited the Gustave Moreau museum in Paris and found in the women and mythology of this nineteenth-century French academic artist both a temple and a magical brothel whose luxuriant tones evoked the forbidden sensuality so adored by the Symbolist poet Charles Baudelaire. That Breton, like Baudelaire and Moreau, should write his fantasy onto the body of woman as simultaneously saintly and erotic tells us much about the orientation of Surrealism. Indebted to the Symbolist *femme fatale*, woman was adored but served the male libido as sensuous muse, an embodiment

The Eye Like a Strange Balloon Mounts Toward Infinity

ODILON REDON; *1882; charcoal on paper; 16⅝ x 13⅛ in. (42.2 x 33.2 cm). Gift of Larry Aldrich, The Museum of Modern Art, New York.*

The Surrealists placed Redon with Seurat and Gauguin as those working against "retinal" modern painting, which propagated "utterly superficial values." Redon's mysterious symbolism and poetic sensibility separated him from the Romantics, who merely illustrated dreams.

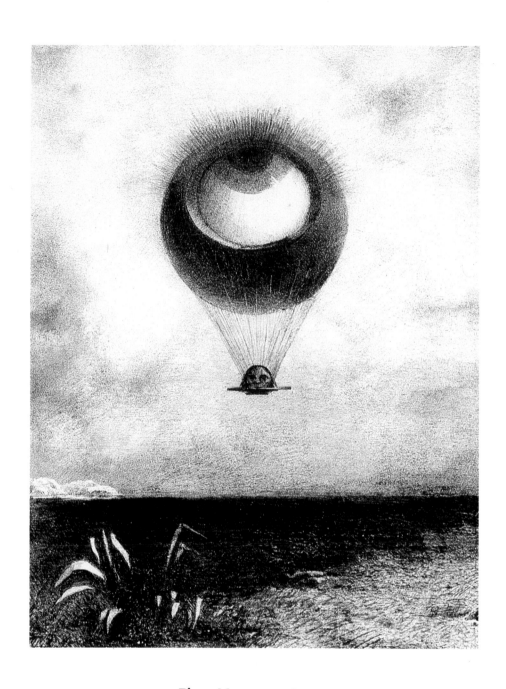

of eros to which the Surrealists would attach the constructions of madness and pornography.

When Moreau's liberal teaching methods were later praised by his more radical students, such as Matisse, Breton chastised their inability to see him also as "a great visionary and magician." The issue of "vision" was taken in a primal sense in Surrealism, since only the "wild eye" of the visionary could see into the abyss. Indeed, one of Breton's central criteria for painting was that it be a "way of thought directed entirely toward the inner life." This was a thin paraphrase of Moreau's own statement about art. Yet interiority had to reveal itself in nonliteral ways. Many artists who apparently painted internal fantasies, such as Swiss painter Arnold Boecklin (1827–1901), were provocative but finally too direct, too literary in their symbols. However, the breadth and diversity of the artists associated with Surrealism guaranteed appreciation for the broad current of fantastic painters. While Boecklin seems to have escaped Breton's list, he was admired by Max Ernst and by the most often cited and important precursor to Surrealism, Giorgio de Chirico.

The Unconscious

Odilon Redon (1840–1916) derived his visions from his dreams and was perhaps the first artist to openly accept the role of the subconscious in creativity. Breton embraced Freud's dream therapy and ranked Redon among those who waged the battle against the "retinal" painters. Redon's source was the eye turned inward, so admired by many Surrealists. That Redon was far more conscious of the plastic values of art set him apart from many Surrealists but his compulsion and biologically derived dream world of weird amoeboid creatures with symbolic titles—admired by his poet friends, such as Stéphane Mallarmé—made him an important precursor. In a black-and-white lithograph Redon has an eye move toward the infinity of the abyss; a perfect image for Surrealist intentions.

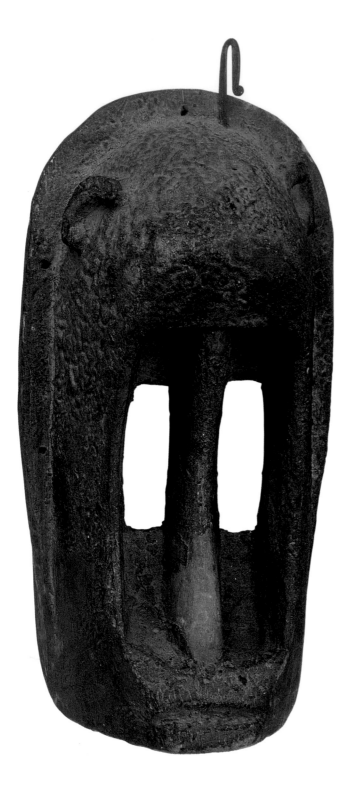

"Black Monkey" Mask

Dogon, Mali; Late 19th century; carved wood;

14 in. high (36.83 cm). Musée de l'Homme, Paris.

The "primitive" was celebrated by all European avant-garde movements in a variety of ways. The Surrealists concentrated on the spiritual aspects—what could be sensed but not seen. They opposed this to those, like Cubists, who concentrated on formal qualities.

The Naïve

Vision was best that came unbidden, hence compulsively defeating the process of will—from Redon's dreams, for example. Those who were untrained were often less restricted and more open to this type of vision. The Surrealists were not the first to celebrate the naïve artist. For instance, Guillaume Apollinaire (1880–1918), the French poet and spokesperson for much of the Paris avant-garde, was a great defender of art from outside the mainstream of Western culture. And his example was closely followed by Breton and others, who were most vocal in support of the naïve.

The greatest of the untaught modern so-called primitive painters was Henri Rousseau (1844–1910), best known as "Le Douanier Rousseau." He began painting part-time after his retirement from the Paris civil service as a gatekeeper and his "naïve" visions were much admired by leading artists of the day. Rousseau wanted to be like the academic painters, not the avant-garde. Yet contrary to an academic belief in an objective world he made no such rational distinctions between phantoms and reality. It was in such an arena, where the possible and impossible could meet, that marked him for admiration. Rousseau's works, like the man, were enigmatic, even to those in the avant-garde, and thus an inspiration to the poetic sensibility.

The Primitive

Nowhere is the primitive or savage eye more readily apparent than outside Western culture, which we assume in our own naïveté to be unmarked by the restrictions of rational discourse. Interest in "primitive" art was marked by the development of ethnographic collections in the 1880s and '90s. And it has been justly remarked that "modern" art, no matter how one defines it, is impossible without the influences of non-Western art and traditions. The specific sources and their uses varied according to the ideas and programs of modern Western artists. Many painters, such as Picasso and Matisse, were taken with the structural simplifications of broad planes seen in figures and masks from Africa, Oceana, and prehistoric Spain. In addition, both used the mask as a metaphor for their excursion into the primitive. Others, such as the early twentieth century German Expressionists and the influential forerunners to Surrealism, the Dadaists, were moved by the power and cadences of African forms and music.

The Surrealists were interested both in the general visionary quality of the so-called primitive state, and with a far more specific, even scientific, ethnographic attitude. Many had large collections of primitive art, ranging with knowledgeable distinction through Africa, Oceana, and the First Peoples of North America. Writers such as Michel Leiris published learned volumes on languages and customs of African peoples. Despite the wide-ranging debates as to which culture was more important to the Surrealists, they generally valued the earlier cultures for their ability to accept in concrete ways the forces in the world invisible to and excluded by the civilized eye.

Alternative Visions

The Surrealists embraced not only naïve and primitive art but that from mediums, compulsive visionaries, and those judged psychotic. Although Breton developed his concept of the interior model for art in 1928 without making reference to the art of the insane, he spent much of his time developing an aesthetic whose cornerstone was madness ("la folie"). Much of this stemmed from his and Max Ernst's early interest and training in medicine and psychology. But the Surrealists were also part of the parallel interests of a larger community.

Apollinaire had certainly been interested in psychotic

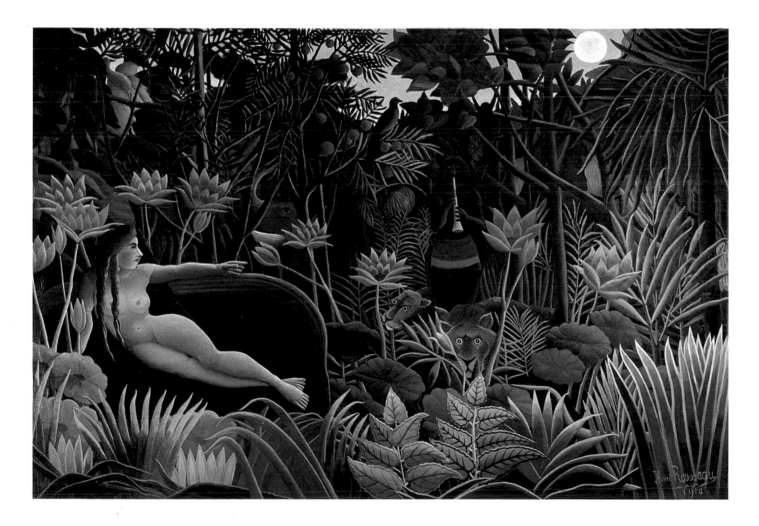

The Dream

Henri Rousseau; *1910; oil on canvas; 6 ft. 8 in. x 9 ft. 9 in. (204.5 x 298.5 cm). Gift of Nelson A. Rockefeller, The Museum of Modern Art, New York.*

Rousseau, a self-taught, retired French civil servant, was lionized by the Parisian avant-garde for his naïve and poetic visions. The hard-edged, concrete rendering of a "dream" naturally appealed to Surrealists.

art, as he had that of the naïve and native peoples, and there had been French surveys of psychotic art circulating in Paris. Principle for the Surrealists was the collection of images produced by institutionalized psychiatric patients across Europe published by the art historian and physician Hans Prinzhorn in 1922, *The Artistry of the Mentally Ill.* Commentators have remarked that it was the images in this text, alongside their own predispositions, that turned the Surrealists from a concentration on art produced by mediums and visionaries to those of the clinically insane. One of the best known cases of psychopathological art was that of the schizophrenic Adolph Wölfli, whose drawings Breton collected as they circulated through Paris and whom he praised in his last published work (1961) as having produced one of the several most important bodies of work in the twentieth century.

By 1925 the Surrealists had penned an open letter under the editorship of the playwright Antonin Artaud (himself interned in an asylum decades later) to the directors of lunatic asylums, proclaiming their patients social victims rather than victims of mental disease. With it we understand how much they romanticized reality in their desire to forge links with unreality.

The Here and Now

The Surrealists admired what they desired but recognized that they did and could not possess it without special effort. Once they accessed their unconsciousness, they felt they could actualize it in the material world, a world in need, so they believed, of a more systematic and positive "vision" than was present in the here and now. By this reasoning the Surrealists claimed two artists as their own, one a famous painter, another an unknown photographer, both quite unrelated except through a Surrealist viewpoint.

Giorgio de Chirico (1888–1978) was an Italian painter who developed the basic ideas of a philosophy toward painting he called "Metaphysical Painting." De Chirico's ideas exerted the most direct and strongest single influence on Surrealism and he is often considered, wrongly, as a member of the Surrealist movement. His ideas were formed by 1911 and solidified by 1915, almost a decade before the advent of Surrealism. His paintings were purposefully "enigmatic." He made them inexplicable by creating scenes using common objects placed in empty spaces with strange perspectives, intended to strip away the common associations which give viewers a context for meaning. In place of the ordinary now stood the unexplainable, a place he felt was prehistoric; a time that presaged that of conscious recording.

The net result was the construction of a type of spatial theater within the painting, which became a staging arena for dreams. Many Surrealists utilized de Chirico's visual stage of dreams and the value he placed on exploring the enigmatic relationships that are possible within the everyday sense of the world. Even as the Surrealists recognized that de Chirico's creative powers were lost in the 1920s, they admitted that "often have we found ourselves in that square where everything seems so close to existence and yet bears so little resemblance to what really exists! It was here, more than anywhere else, that we held our invisible meetings. It was here that we were to be found . . ."

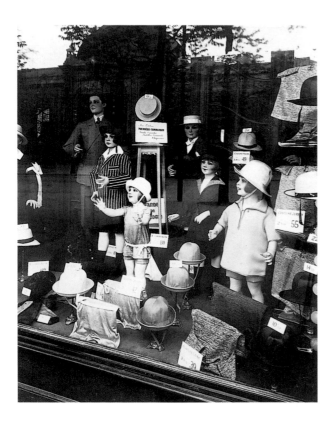

Magasin, avenue des Gobelins

EUGÈNE ATGET; *1925; albumen-silver print; 9⅜ x 7 in. (23.8 x 17.7 cm). Abbott-Levy Collection, partial gift of Shirley C. Burden, The Museum of Modern Art, New York.* Atget was a self-taught photographer whose naïve documentation of Paris accidentally recorded the sense of strangeness within the everyday world. Surrealism celebrated those moments when personal vision allowed one world within another to be seen.

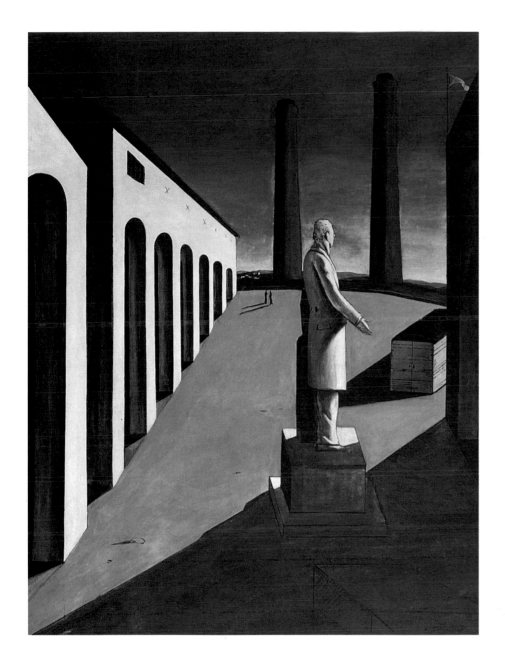

The Enigma of a Day

GIORGIO DE CHIRICO; *1914;*
oil on canvas; 6 ft. 1¼ in. x 55 in.
(185.5 x 139.7 cm). James Thrall
Soby bequest, The Museum
of Modern Art, New York.
The Italian founder of Metaphysical painting, de Chirico was likely the single most significant influence on Surrealist painting, through both his style and the mood of foreboding strangeness he created in his tableaus.

Far more naïve was the photographer Eugène Atget (1857–1927), who taught himself photography in his early forties in order to make a living by providing visual documentation of the older and disappearing architecture and avenues in Paris. With no pretensions to art, Atget seemed single-mindedly devoted to recording the real and was accepted for that. But the Surrealists in the 1920s—particularly Man Ray's assistant, the American Berenice Abbott, later to be quite renowned herself as a photographer—recognized in Atget's works a vision that went well beyond description, to pass into a disturbing, hence profoundly more real, interpretation of the world. The Surrealists published several of Atget's photographs and at his death, Abbott rescued Atget's ten thousand plates for posterity.

The Real

For the Surrealists, the real had to be maintained as a platform for both departure and return, just as dreams and desires were grounded in discoveries made in the world. Photography had the inherent strength of creating a sense of actuality in the world; it began as a document of reality and could continue to use reality as a reference point. This opened up many possibilities for the Surrealists, who employed photography more so than any previous art movement. The academicized painting style of de Chirico offered a similar reference to reality. Atget and de Chirico, from a Surrealist point of view, shared the ability to dislocate normal conventions of time and space by reference to the real. Once dislocated, a viewer was more open to a less linear and rational, more suggestive, or poetic, sense of presence.

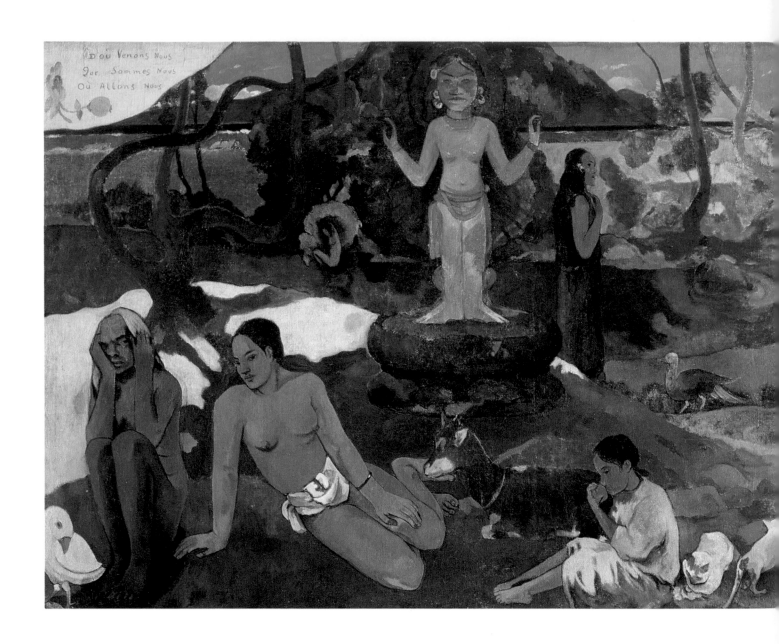

Where Do We Come From? What Are We? Where Are We Going?

PAUL GAUGUIN; *1897; oil on canvas; 54¾ x 147 in. (139.1 x 374.6 cm). Tomkins Collection, Museum of Fine Arts, Boston.*

For modern art, it was Gauguin's flat, bright colors that were important; for the Surrealists,
it was his attempt to refurbish the modern world with a spiritual dimension.

General View of the Island Neveranger

ADOLPH WÖLFLI; *1911; pencil and colored pencil; 39 x 27¼ in.*
(99.8 x 71.2 cm). Adolphe Wölfli Foundation, Kunstmuseum, Bern.
The Surrealists greatly enlarged the European avant-garde's
celebration of the "outsider," expanding the definition (members
of "primitive" cultures) to include mediums, folk-art visionaries,
and the clinically insane. Breton, with many others in Paris,
collected the drawings of the Swiss schizophrenic Adolphe Wölfli.

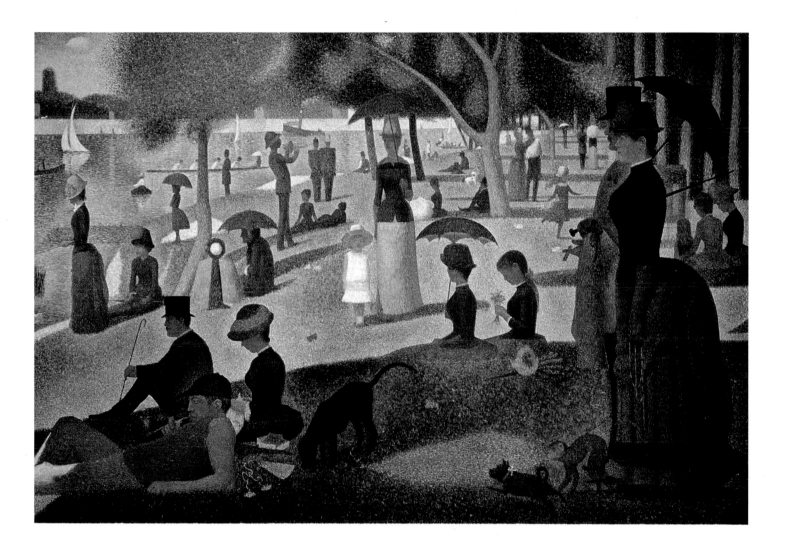

A Sunday on La Grande Jatte

GEORGES SEURAT; *1884–86; oil on canvas; 6 ft. 9¾ in. x 10 ft. 1¼ in. (2 x 3 m).*

Helen Birch Bartlett Memorial Collection, The Art Institute of Chicago.

Despite their rejection of Impressionism, the Surrealists admired
this most retinal of painters because they saw in his strange,
frozen structure and figures "an inward-directed spirit."

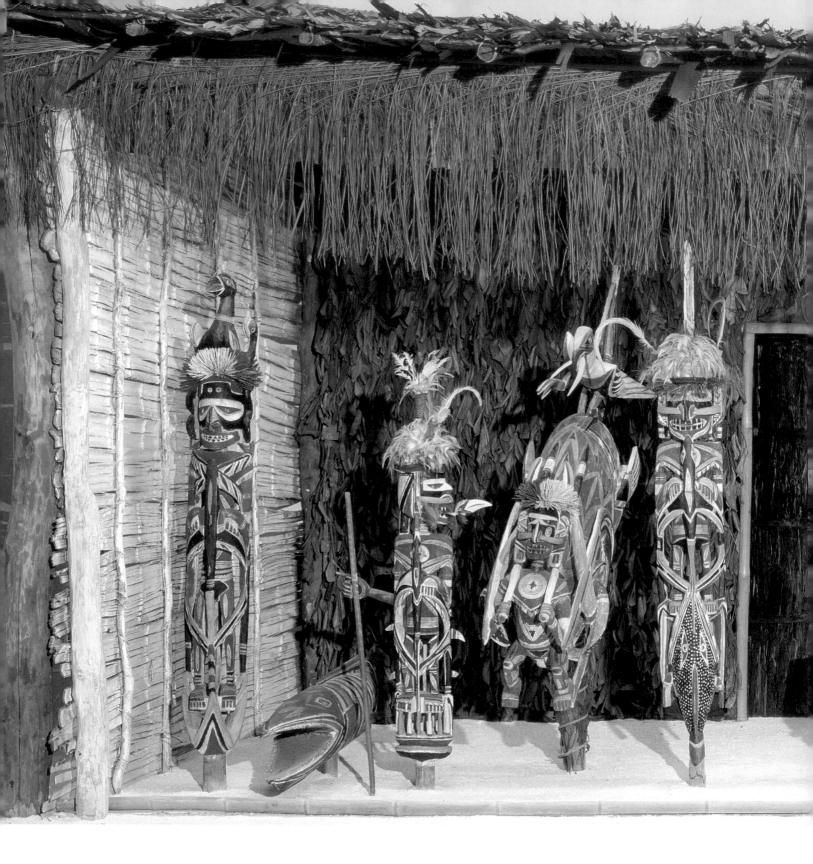

Cult House with *Malanggan*-style Masks

n.d.; Medina, New Ireland; house of wood, bamboo, palm, and croton leaves;
figures of painted wood; 8 x 16 ft. (2.44 x 4.88 m). Museum für Völkerkunde, Basel.
The Surrealists brought an ethnographic attitude to their
study of the "primitive," but they seemed to prefer the arts of
Oceania over Africa because, to them, these were more imaginative.

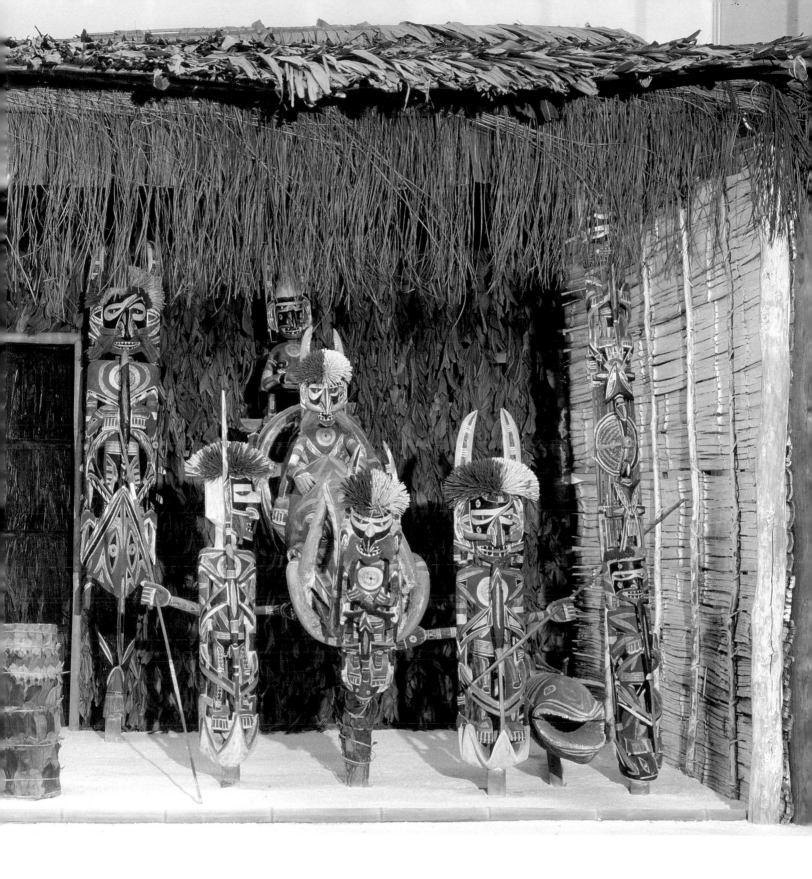

Haida Bear Mask

NORTH AMERICAN INDIAN; *n.d.; paint on wood with turquoise inlay.*
Carnegie Museum, Anthropological Center, Meridian, Pennsylvania.
Proud of their knowledge of primitive art, many
Surrealists collected and displayed it, but eclectically. The
native art of North America, from Eskimo to Hopi, was a
favorite. Max Ernst and Dorothea Tanning owned a
Kwakiutl mask much like the Haida mask pictured here.

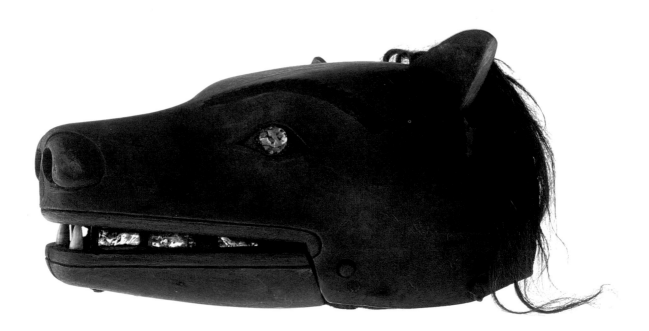

Puberty

EDVARD MUNCH; *1894; oil on canvas; 59 x 43¾ in. (149.8 x 111.1 cm). National Gallery, Oslo.*
Breton singled out *Puberty* as a rare flash of lightning, and Munch as one
whose profoundly tragic perception of life made him incapable of rendering
into paint anything less than what he saw. Here, the young girl's moment of
sexual consciousness is given a symbolic form through the blue-black shadows.

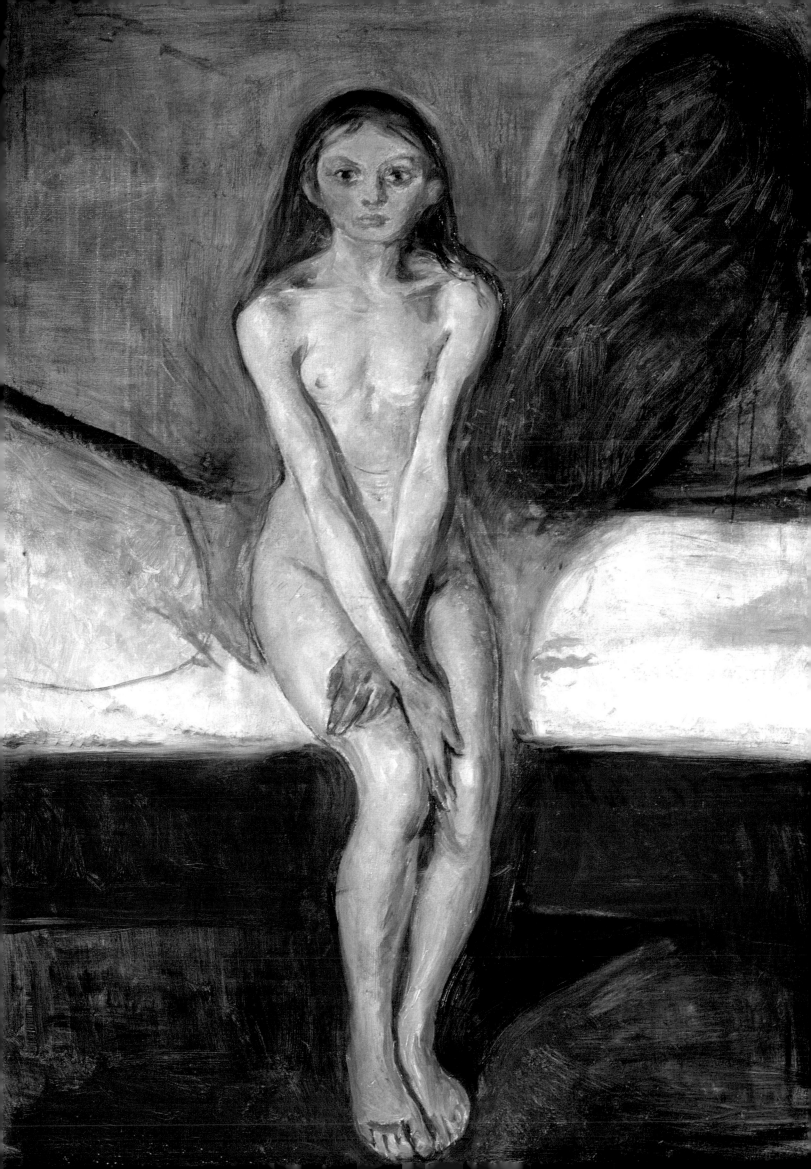

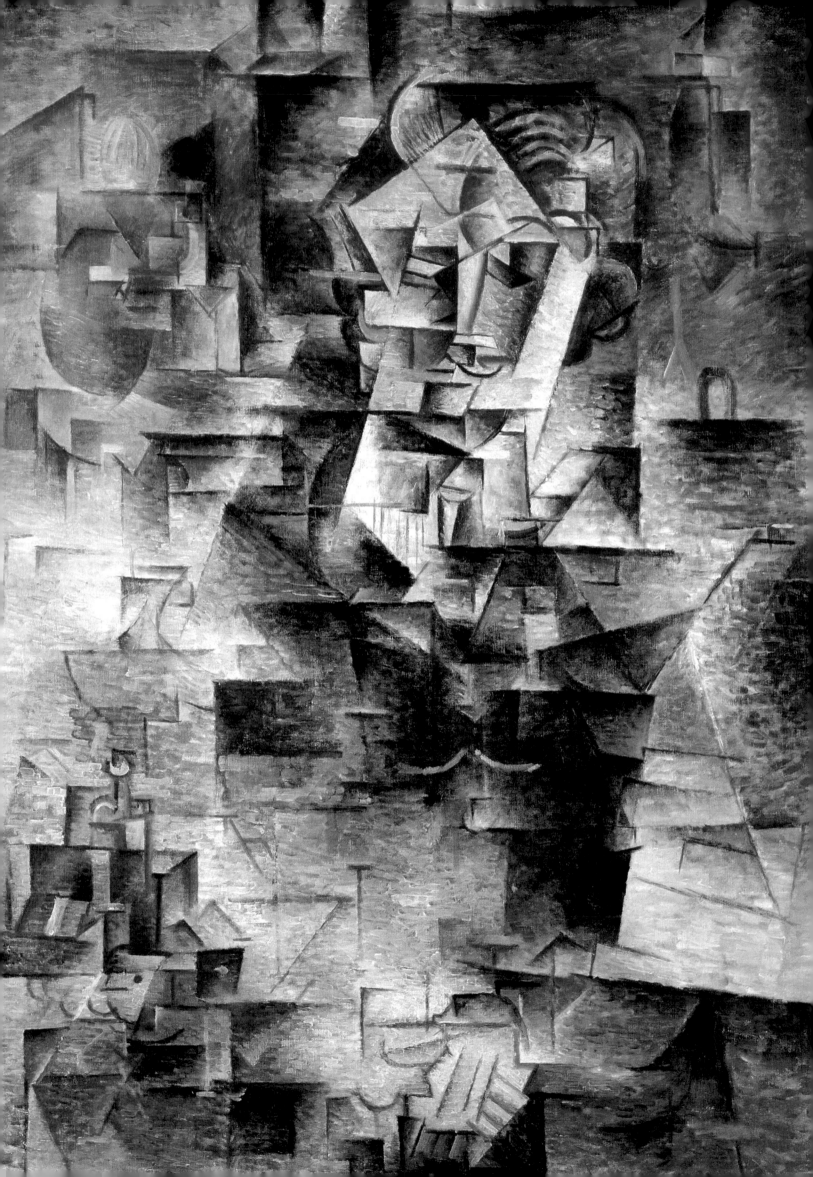

THE EUROPEAN AVANT-GARDE

Europeans at the turn of the century were witness to an incredible outpouring of ideas with regard to art and theory. Most of the Surrealists were active members of one or several artistic movements before and, at times, during their association with Surrealism. Most were well informed of the variety of concepts and beliefs swirling about them. From this state of flux, Surrealism precipitated its aesthetic and many of its techniques.

Cubism and Picasso

Cubism is often considered antithetical to Surrealism. The broken planes of early Cubism are related to an analytical tradition that concerns itself with a visual and systematic breakdown of the object and its restructuring. It is part of the broad current of structural concerns Surrealists rejected as irrelevant. But for Breton "that ridiculous word 'cubism' can never conceal from me the enormous significance of that sudden flash of inspiration" that occurred in Picasso between 1909 and 1910.

In Picasso Breton saw an individual so protean he broke rules and was liberated from categories and labels through his restless sense of internal vision, seeing then bringing into existence things none but poets had envisioned. It was the path and the broad accomplishment that interested Breton. In building this case Breton felt that he was also building the case for Surrealism to avoid and operate outside of systems.

Cubism set the pace for much of what is considered modern art in the early 1900s. But most of those footsteps were not applauded by the Surrealists since they were seen as servile and not as creative. Precisely where the line was to be drawn was problematic since Breton, among others, used as his requirement for art criticism an inner psychic vibration that one simply could sense. He dismissed many artists, well-known Cubists among them, for "propagating utterly superficial values." In many ways, Breton sounds surprisingly like an Expressionist because both movements placed primary importance on the interior state.

German Expressionism

Paul Klee, the Swiss-born artist, was a member of the German Expressionist movement. He never joined the Surrealists but was well known to and showed with them. Breton placed him on his short list in 1924 as one of the few he could call "Surrealist," and as late as 1941 Breton recounted that Surrealism owed a debt to Klee's use of "automatism." Automatism—the free flow of associations—was advanced by Breton as the single most important key to the definition of Surrealism, a path to the inner

Portrait of Daniel-Henry Kahnweiler

PABLO PICASSO; *1910; oil on canvas; 39 x 28⅝ in. (100.6 x 72.8 cm). Gift of Mrs. Gilbert W. Chapman in memory of Charles B. Goodspeed, 1948.561, The Art Institute of Chicago.* The crisp edges and analytic attitude of early Cubism seems opposed to the Surrealist dream world, but Cubism was admired as a movement that heralded the crisis of the object, and Picasso was Breton's favorite artist.

psyche. Klee had been employing automatism since about 1914, when he would close his eyes, turn his mind inward, and automatically doodle on a pad to initiate an image.

Beyond specific influences, Expressionism was a seminal art movement which argued that the source of art was inward. However, the Expressionists referred more to inner "feelings" and these differed from the inner "psychic" sources desired by the Surrealists. The two movements shared an insistence on art deriving from some internal compulsion but the Surrealists argued more for a pathological condition beyond control, rather than an expression of will or spirit. Any artist who lost their compulsion, according to Surrealist stricture, lost their path.

Italian Futurism (1909–16)

Futurism, founded by the poet Marinetti in Italy in 1909, was the most aggressive of the pre-war avant-garde art movements. The Futurists sought art forms that would embody the energy and dynamism of the new century, propelling Italy out of its classical past and into the future of machinery, speed, and violence. André Breton often referred to Futurism in the same breadth as Cubism, as one of the two movements that effectively challenged the past concepts of the "object," placing it in "crisis." The message was simply that Surrealism in the 1920s would take on the next step in the process initiated by Cubism and Futurism.

The Futurist painters married bright colors to the planes of Cubism and set them in newly dynamic relationships, using movement and light to destroy the static quality of the material world. In its sculptural form, Umberto Boccioni's bronze *Unique Forms of Continuity in Space* was a literal attempt to first dissolve then extend material form through "lines of force" and into a fusion with the world around it.

Whether these lines of force were painted or sculpted, composed of words or of music, they were to be set free with the velocities of modern life to merge art, spectator, and life into a new complex whole. The Futurist lines of force were not simply a representation of stop-action or cinematic parallels, although photography and the new medium of film were of important influence, as they would come to be for Surrealism. They were also intended to give form to what is sensed rather than merely seen— the future unfolding of the object simultaneously with this time, the real as a mixture of the seen, the remembered, and the sensed. The desire to communicate on a more fundamental level in a new understanding of the real made both the Futurists and the Surrealists self-proclaimed "primitives of a new and completely transformed sensibility."

The wide range of parallels included the aggressive and the bombastic quality of their declarations and manifestoes. Both movements were founded through passionate beliefs in poetic sensibilities, the prime importance of individual creativity, and an almost absolute sense of personal freedom and liberation. Marinetti developed the concept of "words set free" (*parole in liberta*), the next step after free verse, to free words from the constraints of syntax and create a more instinctual level of communication. This included poems composed anarchistically, distributed across the page in a variety of type fonts, sizes, and densities. Their pell-mell barrage on the senses was deliberate, part of the principles of "simultaneity" and "brutism."

Professed, if not practicing, anarchists, the Futurists believed in violence and the brutalities of raw energy to disrupt and divert life from Italy's "cult" of the past into a new society. Central was the fusion of art to life, leading then, as it still does today, to the use of public performance and moments. Short performances that were non-narrative, often surprising, and always disruptive and shocking were developed. Sharp, explosive sounds such as a gunshot were accompanied with bursts of light, screams, and sudden, unexplained events, which included overselling tickets and physical disruptions in the audience. The audience was to be "brutalized" by input and shocked out of normalcy, precisely what Marinetti was attempting to initiate with poetry.

This was the perfect avant-garde product, picked up by the Dadaists, then by the Surrealists. Shocking the middle class became and often remained the byword of the new. It had political meaning, however, among the class-oriented Europeans throughout the early twentieth century.

Unique Forms of Continuity in Space

UMBERTO BOCCIONI; *1913; bronze (cast 1931);*
43⅞ x 34⅞ x 15¼ in. (111.2 x 88.5 x 40 cm). Acquired through
the Lillie P. Bliss bequest, The Museum of Modern Art, New York.
The Italian Futurists claimed an anarchistic attitude toward the modern world that fueled the ideas in Dada, and eventually affected Surrealism. Boccioni's striding figure throws out "lines of force" to merge form and art with its environment.

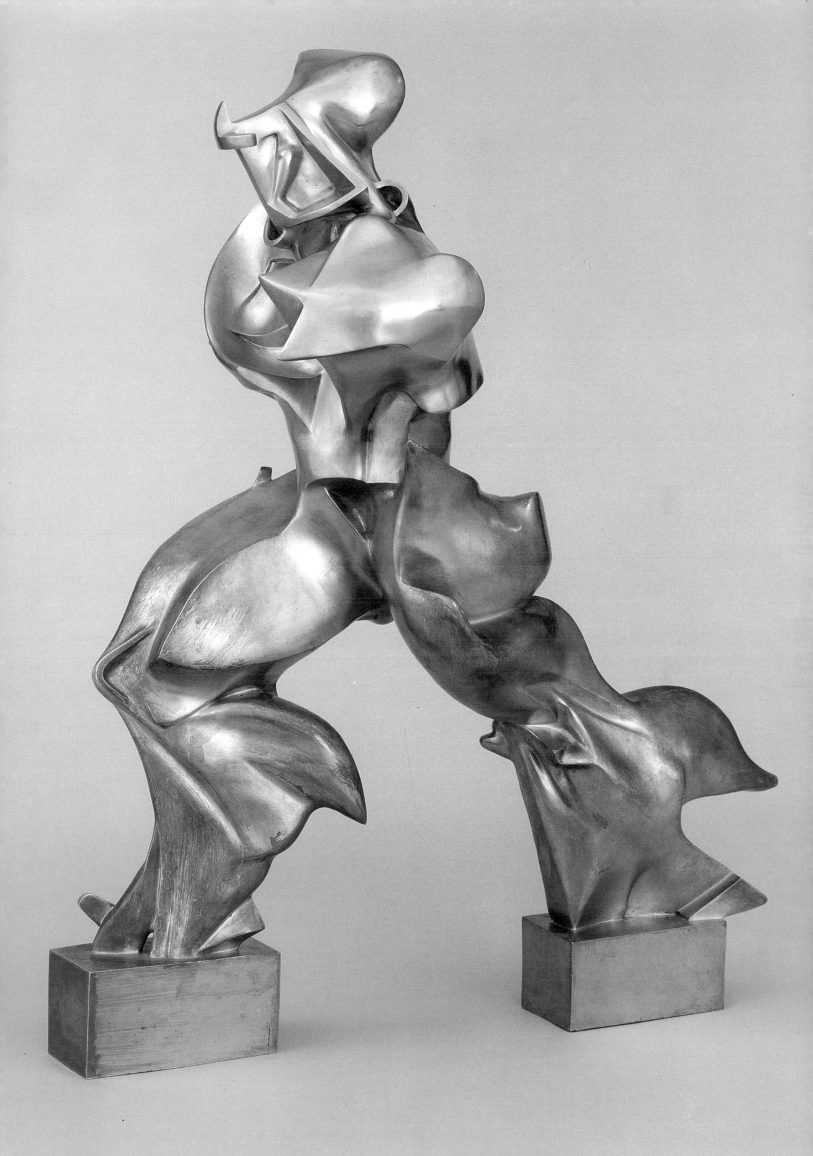

International Dada

The Dada movement was the birthing field for Surrealism. The name was essentially meaningless and the lack of meaning was a major strategy. Randomness was one of their purposive values; by definition it cannot be predicted, thus only the act is codified. The Dada movement refined many of the basic ideas, established the early membership, and eventually became the opposing force to the Surrealists. Francis Picabia, a member of both groups, wrote in 1925 that Breton's surrealism was simply Dada disguised as an advertising balloon for the firm Breton & Co.

Dada was energetic activity organized as a spontaneous gesture against the insanity of a worldwide war. Dada advertised itself as without value but manifested outrage because values had been violated. If rationality brought humanity to the level of world war, argued the Dadaists implicitly, then the true name of reason was insanity. And they would demonstrate the true nature of life: in the leveling of art and life, the reliance on the energies of creativity hurled like a chair into the face of conformity, and the overall program of random yet purposeful destruction, Dada resembled the program of the Futurists and motivated the Surrealists.

Zurich Dada (1916–19)

In Zurich the major vehicle for the Dadaists was their evening performances. Their anarchistic form derived from Futurist models and a typical evening found boisterous students packed into the Cabaret Voltaire ready to sing or snarl along, depending on the performance. These moments often consisted of Futurist techniques, although less scripted, with traditional songs and dances intermixed with free forms. Simultaneity, free words, and brutism—or "noise-music"—were practiced, as when different individuals recited either poems in different languages or nonsense syllables from different corners of the room at the same time, often accompanied by or simply creating noise for its own sake. Some would beat out the rhythms of "Negro" music on drums while Hugo Ball played the piano and his wife Emmy

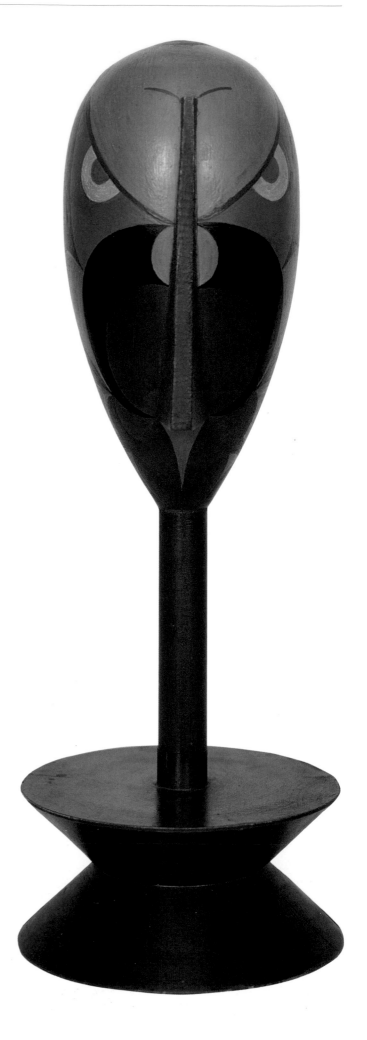

Dada-Kopf (Portrait of Hans Arp)

Sophie-Taeuber Arp; *1918; wood; height 9⅓ in. (24 cm). Kunsthaus, Zurich.*
Taeuber's wooden Dada-heads grew out of her abstract drawings and tapestries, which have simple, primordial shapes that metamorphose from human to animal to containers like a biological system of advancing forms, one evolving from another.

Hennings sang and, with others, danced on stage in Dada costumes.

As Jean Arp remarked, the Dadaists beat furiously on drums of a different measure while the drums of war beat their own staccato in the background. The use of "primitive" rhythms to remind Western culture of its current condition was new but the application of African culture to modernism had been practiced by Cubists and Expressionists for years. Like them, the Dadaists too were modern primitives. In locations other than Zurich, they began to identify their primitivism more with the beat of the machine rather than a simple romantic escapism into a distant or simpler culture. Primitivism was utilized to move artists to think about rather than simply borrow forms. This was a project the Surrealists would continue.

Tzara

The Rumanian poet Tristan Tzara (1896–1963) was the major link between Futurism and Dadaism, openly appropriating their techniques of aggression, provocation, simultaneity, and brutism in his manifestoes and poetry. He also shared the desire for language to operate on some fundamental level. As angry as they were, the Dadaists were not simply out to destroy. They were also driven by the need to communicate. As poets, they gave weight to a concept of poetic space, a place called into existence by creativity; this space was pre-verbal, or, as Ball characterized it, alchemical. But it was not a privileged site of the mind; everyone could be a Dadaist. We are all, or can be, according to their precepts, "artists." For modern art the consequences of this shift in attitude were enormous.

In 1911 the Futurists had been the first to exhibit the drawings and paintings of untrained working-class citizens and children alongside their own—demonstrating that "everyone's soul" was equal in the artistic sense. The Expressionists in Germany published children's drawings a year later in their journal. Giorgio de Chirico and Paul Klee openly praised the intuitive domain of children, where mystery flourished prior to the later onslaught of adult reason. Tzara, as poet, argued that anyone could be a poet by cutting up printed sentences, then tossing and selecting the words at random from a bag. Scissors and chance were the great equalizers, transplanting the "authority" of the author/artist to everyone.

When Tzara moved in 1920 to Paris, where his writings were well known, he made the Paris Dada movement official, with a group of poets—Breton, Paul Eluard, Philippe Soupault—who would break with him to form Surrealism.

Arp and Taeuber

There was no such thing as Dadaist art, nor did it ever develop beyond an attitude. Ball replaced the cabaret in 1917 with the Dada Gallery and showed Futurists, Cubists, and Expressionists. Among the few to develop Dada principles in relation to the visual arts in Zurich were Hans Arp (after 1939 signed "Jean Arp") and the Russian designer and dancer Sophie Taeuber. Both in Zurich by 1915, they worked in an unusual, collaborative effort which they felt was another way to defeat the egotism inherent in artistic creation. In earlier rectilinear forms, influenced by a study of Cubism, and in 1916, using curvilinear forms, they continued to withdraw any

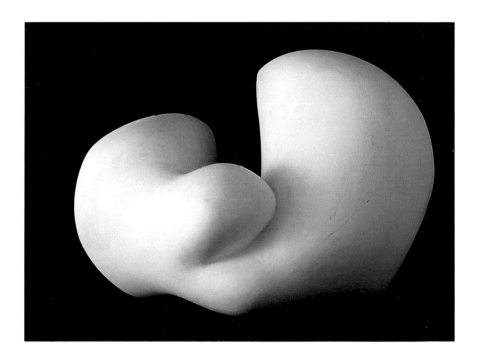

Human Concretion

JEAN (HANS) ARP; *1935; cast stone (1949, after the original plaster); height 19 in. (49.5 cm). Gift of the Advisory Committee, The Museum of Modern Art, New York.* Arp, one of the founders of Dada, was the greatest formulator of chance as an active principle in the world. His later work within Surrealism conveyed a sense of organic growth, as if by chance formation, without picturing anything in the world.

mark of individuality to move toward an art considered more "infinite and eternal." They created "paper pictures" arranged according to laws of chance—a kind of Cubism without creator—first from linear, torn sheets, then as collages of abstract, curvilinear forms, to include textiles, wooden containers of interfitting forms, curved woodcut reliefs, and Taeuber's marionettes and "Dada-heads."

They declared these organic looking drawings and collages "Realities in themselves, without meaning or cerebral intention. We . . . allowed the elementary and spontaneous to react . . . like nature, [were] ordered according to the laws of chance." These organic abstractions, or as Arp referred to them, organic "concretions," provided him, if not Taeuber, a basis for development for the rest of his life, and can be seen in his 1935 *Human Concretion*, one of many such works carried out during his "Surrealist" period but clearly embodying Dadaist principles. Sculpture as a process of growth equivalent to nature established a biological metaphor for art and had a profound influence on sculpture in the twentieth century. For the Surrealists, Arp's work not only challenged past understandings of an object but moved the object into the less defined, more provocative realm of the poetic imagination.

Taeuber's marionettes and "Dada-heads" carried out the all-important merger between the mechanical and the natural. These seem interchangeable in form with her abstract drawings and tapestries, which have simple, primordial shapes that metamorphose from human to animal to containers. The combination of the biological and mechanical has a long, highly charged life within the Dadaist and Futurist admiration for the machine.

Cologne Dada & Max Ernst (1919–22)

Arp and Taeuber moved to Cologne in 1919 and helped motivate the Dada movement with Arp's old friend Max Ernst (1891–1976), who developed their element of chance into hallucination. Ernst knew the work of de Chircio and Klee, had studied philosophy and psychiatry, and arrived at a profound disgust of the world of bourgeois values through the horrors of four years of war service. By 1919 he was staging Dada events that used much of the Zurich ideas to openly attack middle-class concepts of art and life. Under Arp's influence, Ernst began producing collages using random combinations from a multitude of established images in newspapers and journals.

Ernst's drawing *Stratified rocks, nature's gift of gneiss iceland moss . . .* (1920) pictures the organic shapes that nature offers, much in the abstract manner of Arp, but underneath the image is a printed reproduction the artist has enhanced with ink and opaque watercolor (gouache) to move it into a more extraordinary realm. This was a process Ernst felt would "transform the banal pages of advertisement into dramas which reveal my most secret desires."

Unlike Arp, Ernst often found his images "ready-made" but he "selected" them by some psychological resonance, a chance encounter between himself, his own psyche, and the image. Other collages from this period construct mechanical images from both linear and curvilinear forms, apparently in some relation to the biomechanical forms used by Taeuber.

Ernst's ready acceptance of psychological states and conditions, particularly the dream-work in Freud's psychoanalysis, parallel the interests and development of Breton. The use of ready-made images—already part of a broad, newly emerging practice in Europe—and especially his reliance on chance encounters as the elemental embodiment of his desire made Ernst a Surrealist from the very beginning. Breton had heard of the Cologne "Dadamax" in Paris and staged an exhibition of his work in 1920, an event many take as the beginning of Paris Dada. In 1921 another of the Paris poets, Paul Eluard, traveled to Cologne to have Ernst illustrate a volume of his poetry.

Berlin Dada (1918–20)

In 1917, Richard Huelsenbeck arrived from Zurich where his own interests in politics coincided with Berlin's political circumstances to lead a Dada group toward an openly political art. Although the Dadaists generally rejected political involvement—something that separates them from the later Surrealists—it was not simply war but a wider crisis in European culture that concerned them.

Huelsenbeck published manifestoes and journals, several aimed at the working class, and helped maintain an interest in mass communication. Colleagues like John Heartfield designed covers for commercial magazines and literary books of social conscience. Artists such as Raoul Hausmann and Hanna Höch were less constrained by the needs for public communication but were guided as well by political and social conscience. An early (1919–20) photomontage by Höch, *Cut with the Kitchen*

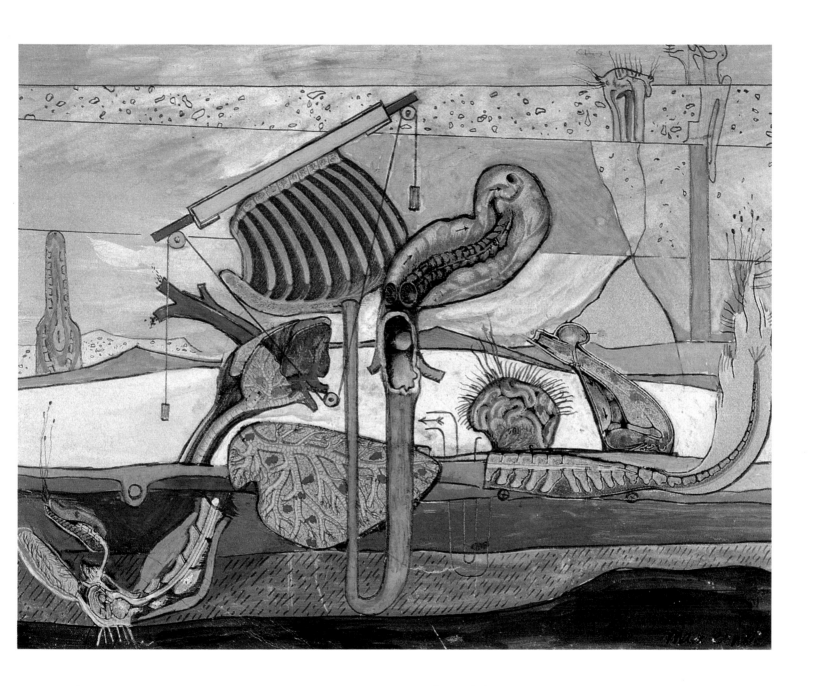

Knife Dada through the Last Weimar Beer Belly Cultural Epoch of Germany, shows a Futurist derived, Dadaist hodgepodge of images. Its mania celebrates Dada, but its title, images, and compositional details direct it as a feminist and communist attack on the liberal politics of the Weimar Republic formed in Germany after their defeat in World War I.

For the Berlin Dadaists, the use of photographs and the technique of photomontage became primary tools in their work. They were influenced by the Futurists and the Russian avant-garde, whose artists had wedded art to the

Stratified rocks, nature's gift of gneiss iceland moss 2 kinds of lungwort 2 kinds of ruptures of the perineum growths of the heart (b) the same thing in a well-polished box somewhat more expensive

MAX ERNST; *1920; anatomical engraving altered with gouache and pencil;*

6 x 8⅛ in. (15.2 x 20.6 cm). The Museum of Modern Art, New York.

Ernst was acknowledged as a Surrealist before Surrealism, even as he was a Dadaist. Under the influence of Arp and his own orientation, Ernst accepted a world that was not separate from art.

Russian Revolution, and a faith in technology that held promise for their own communist future. This equation was a powerful vision on behalf of the importance of art—its promise of the dream of revolution—and the path it should take.

New York Dada (1913–21)

Francis Picabia (1878–1953), a Cuban citizen of French and Spanish descent and a close friend to Marcel Duchamp, was the first Dadaist to arrive in New York to see his work in the 1913 Armory show. This was the first important American exhibition of modern European painting and the "Cubist" works of Picabia and Duchamp had become national scandals. Circa 1912 to 1915, between Paris and the United States and in proportions still unknown, the two artists together developed a different interpretation of "pure painting" from their Parisian colleagues. For them, art was purified by thought rather than developed through abstraction into pure art. Ultimately they would decide that the art of form was a thing of the past.

The biomechanical model emerging across Europe was employed by Picabia and Duchamp for its humorous and ironic qualities as applied to people, culture, and relations. In Picabia's *I See Again in Memory my Dear Udnie* (1914) the flat, abstract forms refer mostly to a biological world through their curved forms but they also reference the mechanical world. According to Picabia, the forms and title of the work derived from his memory of a dancer he admired on shipboard, but were modified through his own erotic dreams. Both he and Duchamp loved word play, frequently using anagrams as titles; in this case "udnie" is likely the anagram for the English slang "nudie."

Like Duchamp, Picabia soon renounced the tradition of large oil paintings and began to make ironic drawings that rejected both Cubism and abstraction. He used invented machines whose title and general biomechanical look were both a celebration and a condemnation of the colonization of the human by the mechanical culture. The subject of his *Amorous Parade* (1917), made on one his several journeys to New York, is a metaphorical conversion of the biological sex drive into and through machinery.

Too anarchistic, subversive, and wealthy to remain in any one place for long, Picabia had moved to Barcelona by 1916–17, and joined the Zurich Dadaists in 1919. He left his biomechanical works with Arp, who transferred their knowledge to Ernst in Cologne. That same year Picabia moved to Paris, where Duchamp joined him and the Dada poets. Picabia eventually associated himself with the Surrealists but also kept his own counsel throughout his life, independent of Breton. The same can be said for Duchamp, who felt Dadaism and Surrealism provided useful attempts to reshape the nature of art, but were ultimately too limiting.

ADE AMOUREUSE

Amorous Parade

FRANCIS PICABIA;
1917; oil on board;
37 x 28 in. (95.25 x 72.39 cm).
Collection of Mr. and
Mrs. Morton G.
Neumann, Chicago.
As with his collaborator
and friend Duchamp,
Picabia prodded the sexual
practices of society by
"picturing" them as me-
chanical, but never with-
out humor. These small
mechanical drawings
are paintings that refuse
the issue of painting.

Duchamp

When Marcel Duchamp (1887–1968) arrived in New York two years after the Armory show he was already notorious. He immediately began work on one of the most famous and problematic works of the twentieth century, *The Large Glass: The Bride Stripped Bare By Her Bachelors, Even*. Conceived in Paris by 1912 it came at the end of a series of paintings exploring the same theme: a bride, bachelors, and a range of cultural customs circling courtship, sex, and desire implied in witty but privatized commentary. Here, the bride remains above the fray in perpetual separation from the nine frustrated bachelors below. They and their elements of desire are "represented" through fusion of abstract biomorphic and mechanical forms and processes. Originally mounted on

glass so the visible world became part of the courtship, it was broken in 1923 during shipment. Duchamp accepted the act of chance and declared the work finished at that point by piecing it together, providing the heavy frame, and allowing the fortuitous cracks to remain visible.

Even more radical was Duchamp's acceptance by 1912 of the artifacts of the world as "ready-made" art, or those to which he made small adjustments and designated "assisted ready-mades." Thus a metal drying rack for bottles purchased in a hardware store was exhibited as is, while a reproduction of Leonardo da Vinci's famous *Mona Lisa* was newly hung with a mustache added. Duchamp was a master chess player and used chess as his model for art as strategic play; his moves are often designed to resonate on several levels. The mustache and title—*L.H.O.O.Q.* is a

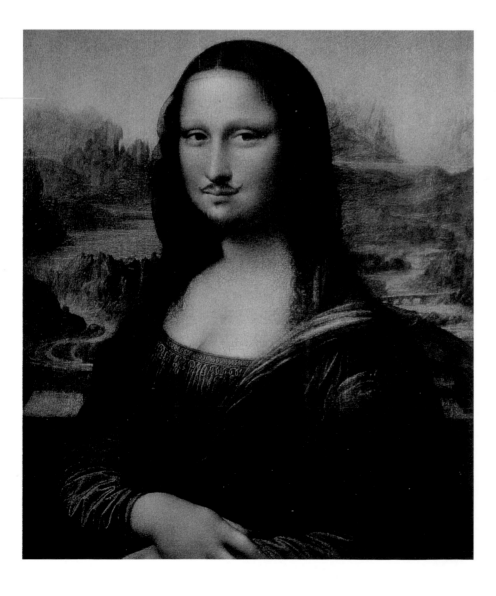

L.H.O.O.Q.

MARCEL DUCHAMP; *1919; reproduction of the* Mona Lisa *altered with pencil; 7 x 5 in. (19 x 12.7 cm). Private collection, New York.* In Duchampian terms, this is an assisted ready-made, and, like most of his work, it operates on several levels of meaning. Grafitti desecrates the sacredness of art; the title marks the subject as a sexual woman ("L.H.O.O.Q." is a phonetic anagram for French words indicating sexual longing); with the mustache "he" marks "her" as the cross-construction of gender roles.

The Large Glass: The Bride Stripped Bare By Her Bachelors, Even

MARCEL DUCHAMP; *1915–23; oil, lead wire, foil, dust, and varnish on glass; 8 ft. 11 in. x 5 ft. 7 in. (231.1 x 170.1 cm). Bequest of Katherine S. Drier, Philadelphia Museum of Art. The Large Glass is Duchamp's complex end to a series dedicated to developing the analogies between biology, the mechanical, and social customs and practices.*

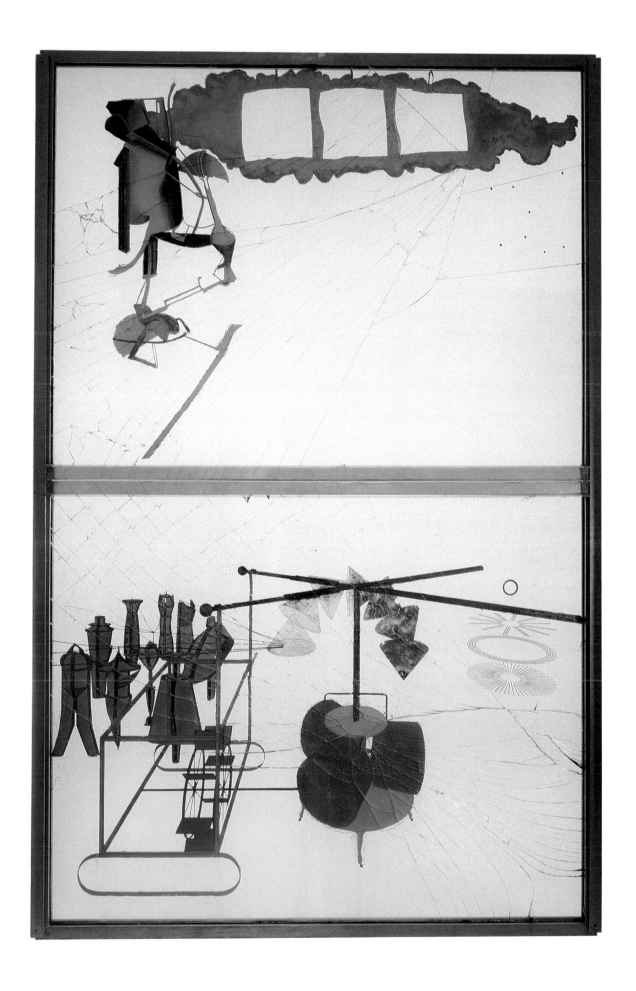

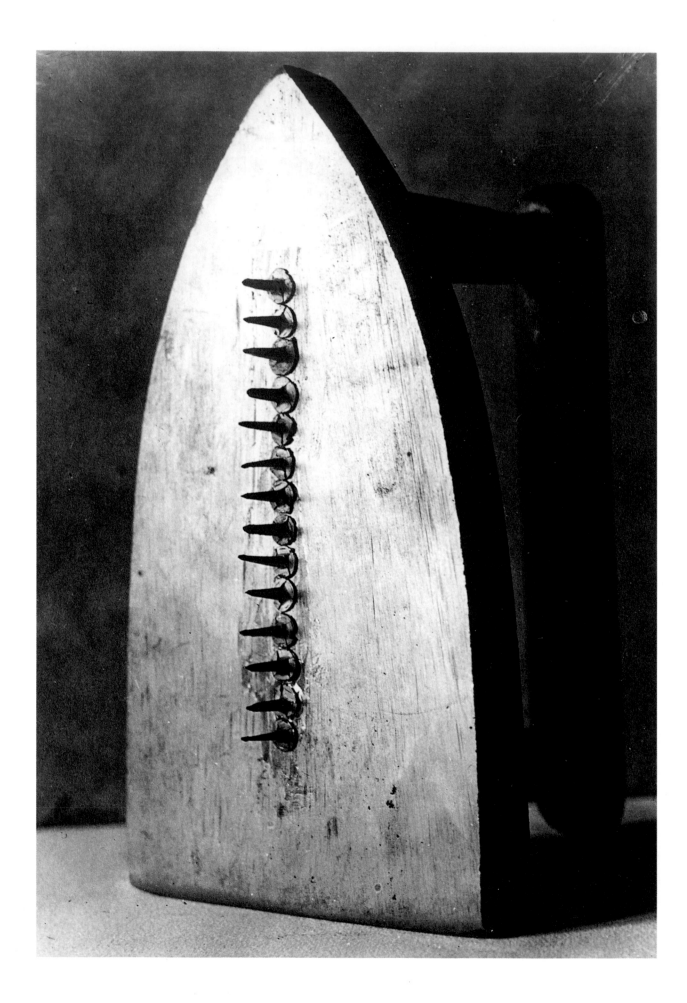

phonetic anagram for French words which indicate that the Mona Lisa has sexual longing—are a Dada gesture to profane the sacred "high" art of an insane culture. To sexualize the asexual and to convert gender through a mustache, for example, transforms expectations of art and the culture that spawns it on several levels. Similarly *The Large Glass* not only "transformed" bride and bachelor into machines but acknowledges that modern culture frequently acts in this manner by identifying people and values through machines; i.e., Duchamp's art transforms but also testifies to what has already occurred.

When Duchamp adopted a feminine pseudonym after 1920, he marked himself as he had marked the *Mona Lisa*. The name, one the artist applied in his work as both author and patron—"Rrose Sélavy"—was a phonetic transcription of the phrase "Eros, c'est la vie." Thus Duchamp, the male as female, called attention in a witty way to the fact that "eros" was a principle, a way of life.

Duchamp turned away from art as an object by experimenting with a series of optical discs and constructions that dematerialized not simply the object but the conceptual frame for art "work." Ultimately he rejected the making of art in favor of a life playing chess, a decision that he periodically violated but one which provided a sense of integrity to his speculations. As arcane as his concepts may seem, he has become the most important single artistic influence in the later part of the twentieth century.

Man Ray

The direct impact of Picabia and Duchamp on American art was very limited until the late 1940s to mid-1950s, when painters such as Robert Rauschenberg and Jasper Johns,

the composer John Cage, and the choreographer Merce Cunningham emerged. Only Man Ray (1890–1977), an American artist from Philadelphia, came under the immediate influence of Dadaism and Surrealism. A collaborator of Duchamp's in New York, Man Ray's "assisted readymade" *Gift* is an everyday object, a mass-produced flat iron, moved out of the ordinary world with the addition of a row of carpet tacks. The function and concept of the iron is graphically denied, and is turned into something else entirely, an instrument of surprise as well as refusal. This sense of aggressive refusal is Dada; the sense of surprise is Surrealist. This is an element in most of Man Ray's work. Duchamp found in Man Ray not only a chess partner but a native American anarchist in spirit.

By 1918 Man Ray was using a spray gun and stencils rather than a brush to create "aerographs" of abstract, ethereal shapes. Turning to photography, it became his major interest after he joined Duchamp in Paris in 1921 for the fermentation between Dadaism and Surrealism. He "accidentally" rediscovered an older cameraless photographic image process by leaving objects on top of sensitized paper and exposing them to light. These "photograms" he renamed "rayographs." Something similar happened with the accidental rediscovery of "solarization," where the momentary overexposure of a negative gives a partial tone reversal in photographic images and creates a dark line at the boundaries of the reversal. Rayographs, solarizations (or "Sabattier effects"), and spray paintings were all negations of conscious technique. All gave fugitive effects that could not be predicted or exactly defined and an image that indicated a mysterious content on the other side of reality.

Gift

MAN RAY; *Replica of lost original of 1921; flatiron with metal tacks; height 6 in. (16.5 cm). Collection of Mrs. and Mrs. Morton G. Neumann, Chicago.* Man Ray, an American, joined Duchamp and Picabia in New York Dada, then moved to Paris to participate in the formulation of Surrealism. His quiet outrage could rarely be sensed, but *Gift* embodies it by using humor to thinly disguise something more threatening.

Rayograph

MAN RAY; *1922; gelatin-silver print, 9⅜ x 7 in.*

(23.8 x 17.7 cm). The Museum of Modern Art, New York.

Best known for his photography, Man Ray
advocated chance encounters in a field considered
precise and mechanical, for chance could docu-
ment and reveal what photography overlooked.

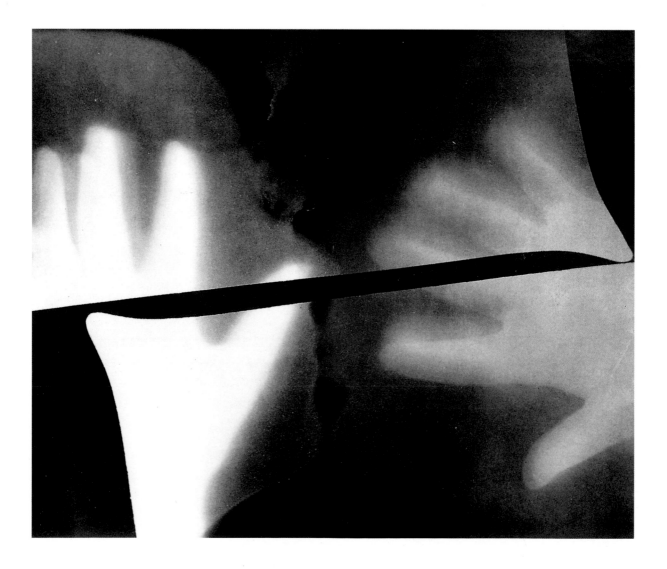

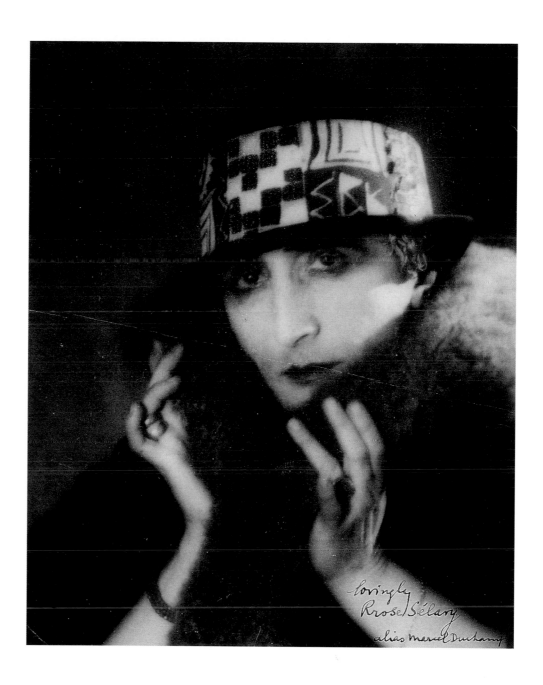

Marcel Duchamp Dressed as Rose Sélavy

MAN RAY; 1924; silver-gelatin print; 8 x 6¹³/₁₆ in. (21.5 x 17.3 cm).

The Samuel S. White, III and Vera White Collection, Philadelphia Museum of Art.

The issue of transformation was at the core of Duchamp's art, as it is
for much twentieth-century art. To restrict this process to simply the
materials of art was too constricting for someone interested in the broader
spectrum of culture; hence *"eros, c'est la vie"*—or Rrose Sélavy—was born.

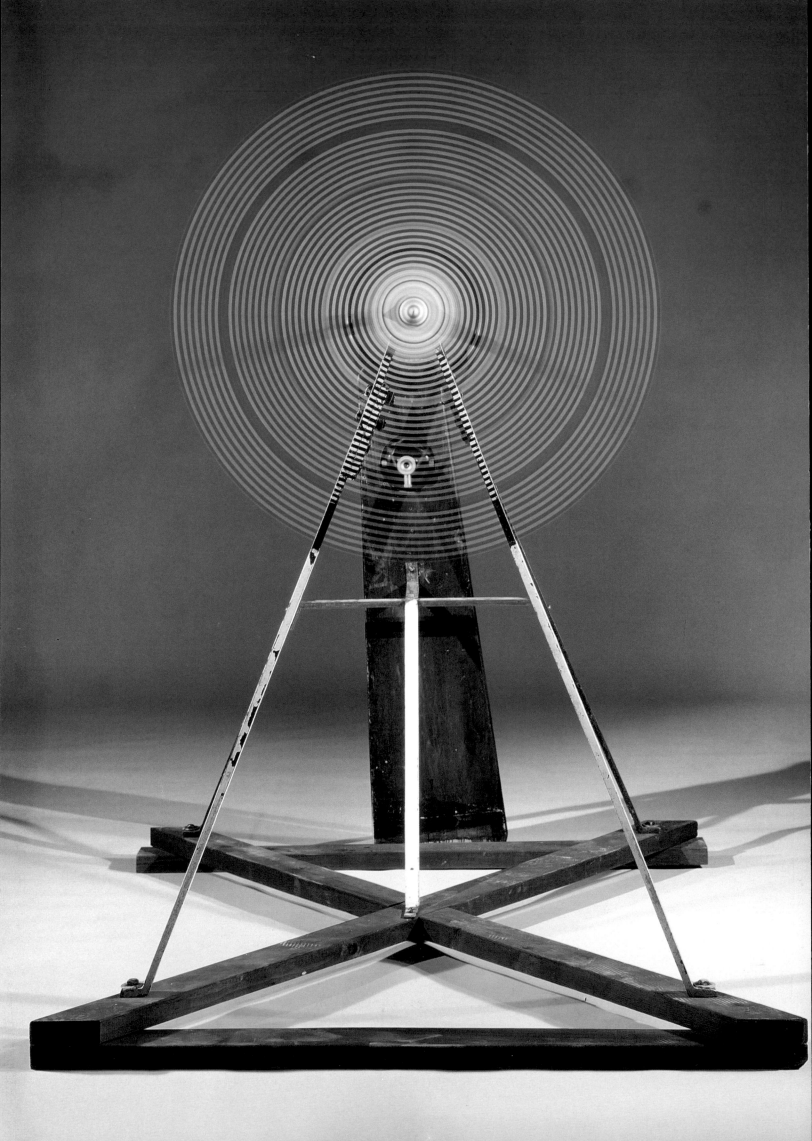

Dance You Monster, to My Soft Song!

PAUL KLEE; *1922; mixed media on gauze mounted on paper; 17¾ x 12⅞ in. (45 x 32.7 cm). The Solomon R. Guggenheim Museum, New York.* Klee was a singular European talent who aligned himself with the Expressionist movement. He was greatly admired for his childlike, magical, and yet powerful images, often cultivated from the unconscious.

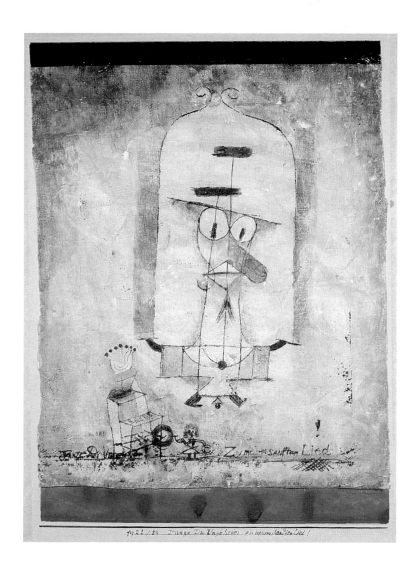

Revolving Glass Plates (Rotative Plaques)

MARCEL DUCHAMP; *1920; glass, metal, and wood; 73 x 48 x 40 in. (185.4 x 121.9 x 101.6 cm). Gift of Collection Societé Anonyme, Yale University Art Gallery, New Haven, Connecticut.* Optics and the machine, long interests of Duchamp's, are used here to literally dematerialize the physical world through spinning glass plates. First a Dadaist, then a Surrealist, and finally an independent, Duchamp was the first to reject painting as a backward-looking practice in art.

Fountain (by R. Mutt)

MARCEL DUCHAMP; *1917 (original lost; 1964, third version); urinal turned on its back; 24 in. high (60.96 cm). Bettman Archives, New York.*
One of Duchamp's several "ready-mades," the *Fountain* was likely the most outrageous. Designed to test the policy limits of an art exhibition, it lives on as an enduring test of the limits of art, which was a lifelong project for the master chess player, Duchamp.

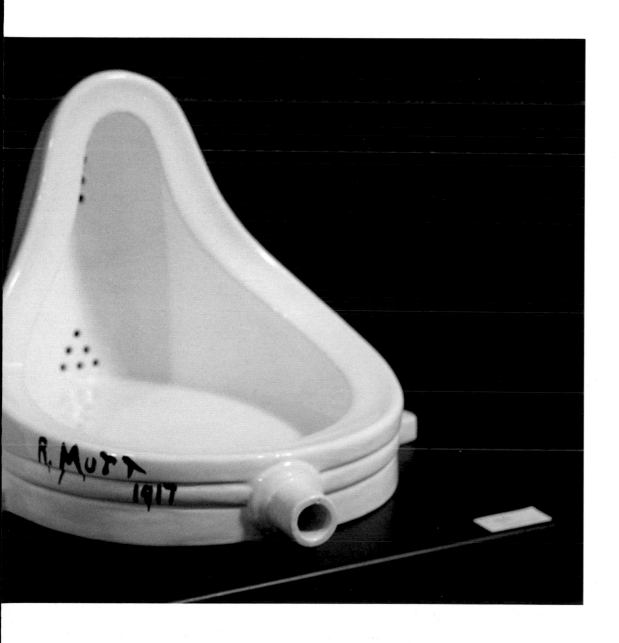

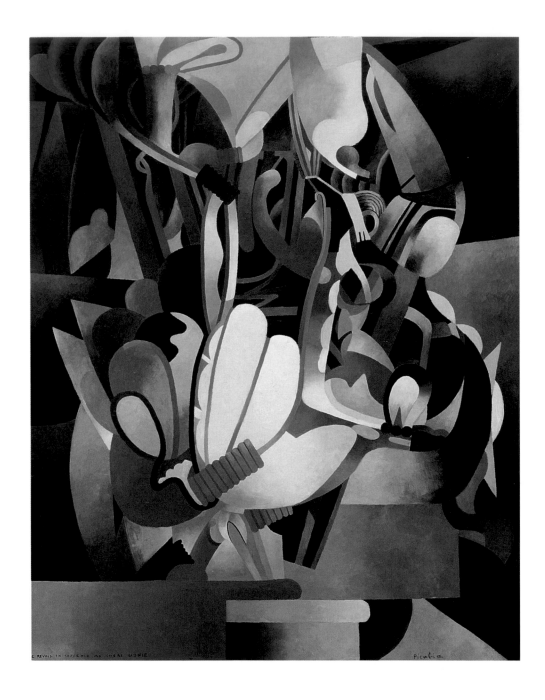

I See Again in Memory my Dear Udnie

FRANCIS PICABIA; *1914; oil on canvas; 8 ft. 2 in. x 6 ft. 6¼ in. (250.2 x 198.8. cm).*

Hillman Periodicals Fund, The Museum of Modern Art, New York.

Picabia was an international gadfly for Dadaism. This pre-Dada painting
demonstrates—with its combination of memory, humor, cubism, biological, and
mechanical references—how painting is simply one "technique" in the realm of art as idea.

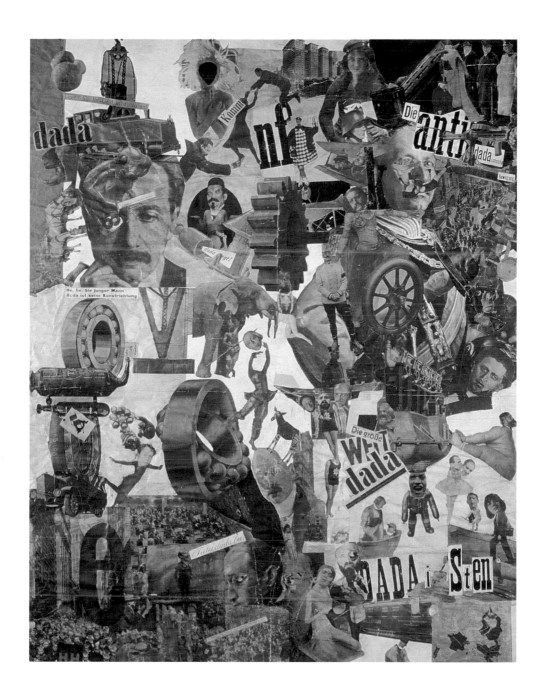

Cut with the Kitchen Knife Dada through the Last Weimar Beer Belly Cultural Epoch of Germany

HANNA HÖCH; *1919–20; collage of pasted papers; 44⅞ x 35 in. (113.9 x 90.1 cm). Stiftung Preussicher Kulturbesitz, Berlin.*

Höch's large photomontage functions on several levels as a complex Dadaist, feminist, and anarchist critique of the leftist politics of the German Weimar Republic. The chaotic composition is a metaphor for the political destabilization promoted by the Berlin Dadaists.

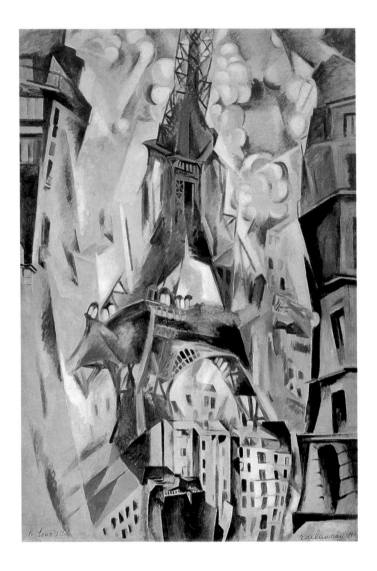

Eiffel Tower

ROBERT DELAUNAY; *1926–28;*
conté crayon on paper; 24 x 18¾ in.
(62.3 x 47.5 cm). The Solomon R.
Guggenheim Museum, New York.
Delaunay was one of the most
celebrated artists of the modern
movement in Paris, adding bright
colors to Cubism to deconstruct
the Eiffel Tower. But his quest
for pure painting as the "new
spirit," pursued by so many,
was rejected by Surrealism.

The King Playing with the Queen

MAX ERNST; *1944; bronze (cast 1954, from original plaster);*
38 in. high (97.8 cm.), 18¾ x 20 in. at base (47.7 x 52.1 cm).
Gift of D. and J. de Menil, The Museum of Modern Art, New York.
The figure of the king originated from a variation of
Ernst's frottage technique in 1927; thus it was a mythological
figure located in the psyche. The work was made for a
proposed exhibition which was to center around chess playing,
and testifies to the importance of the game as a model for art.

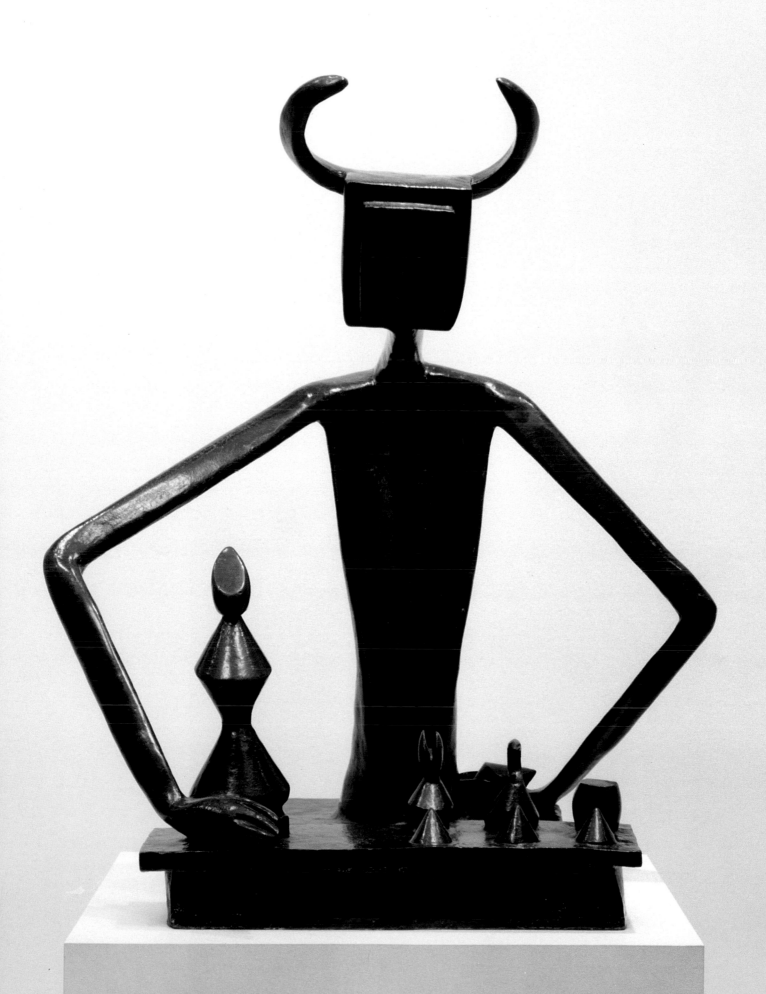

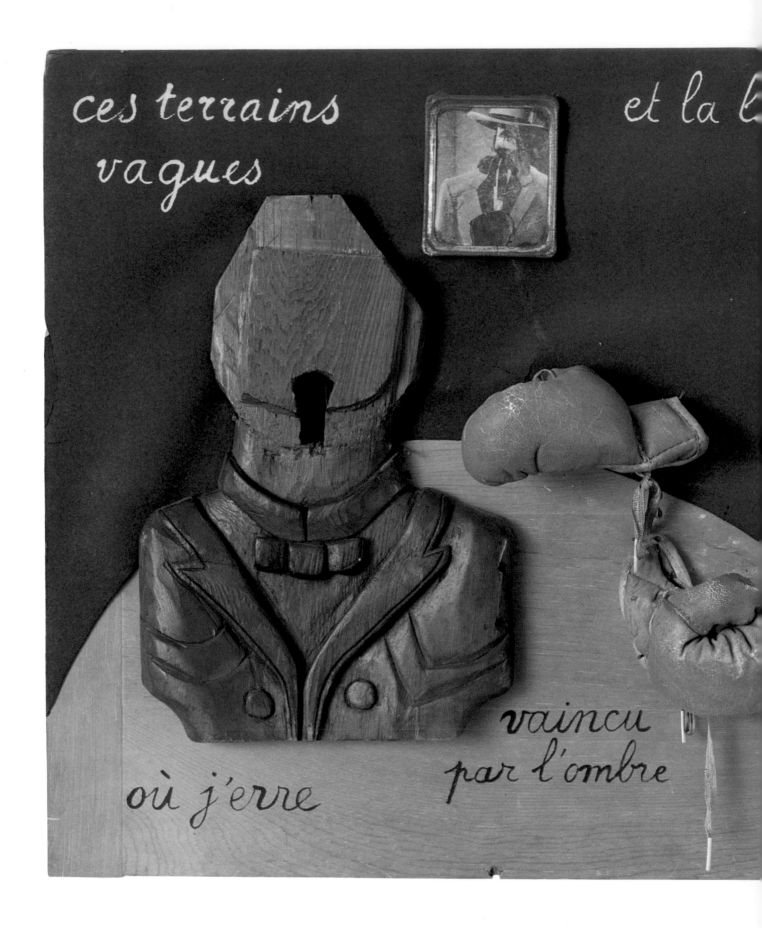

ces terrains
vagues

et la b

où j'erre

vaincu
par l'ombre

accrochée
à la
maison
de
mon coeur

THE SURREALIST REVOLUTION 1924-1929

The Surrealist movement was begun officially late in 1924 with the publication of André Breton's first Surrealist manifesto, but not without the intercession of several tumultuous years.

Paris Coalescence

With the end of World War I the Surrealists benefited from the gathering in Paris of those Dada artists earlier sequestered in isolated cities. The emergence of Surrealism can be viewed as a physical coalescence of the Dadaists. Picabia and Duchamp were in Paris in 1917 and 1919 with intermittent visits; Man Ray made a permanent move in 1921; Tzara moved in 1920, with Arp and Taeuber arriving the same year; Ernst followed from Cologne in 1922. In addition, the so-called School of Paris was an amalgam of pre- and postwar avant-garde movements. Until the worldwide Depression in 1929 it was a glorious and fateful period, and Breton was to be its maestro.

Poem-Object

ANDRÉ BRETON; *1941; assemblage; 18 x 21 x 4⅜ in. (45.7 x 53.3 x 10.9 cm).*
Kay Sage Tanguy bequest, The Museum of Modern Art, New York.
Developed in the 1930s by Breton, the poem-object combined images and text. Fragments of words and visual objects were sectioned off from one another, but intended to accidentally exert an influence on each other; a case of "reciprocal exaltation," wrote Breton.

Breton, Louis Aragon, and Philippe Soupault, the founders in 1919 of the avant-garde magazine *Littérature*, had served in the war but had remained in contact with the vocal and active literary avant-garde figures in Paris. The more nihilistic figures—such as the enigmatic dandy Jacques Vaché and the outrageous English artist-writer-dancer-boxer known as an American, Arthur Cravan—joined with the equally avant-garde but more moderate voices aligned before the war with the development of "modern" visual art, such as Apollinaire, Max Jacob, André Salmon, and Blaise Cendrars. This was a complex and volatile mix.

Although Dadaism was "officially" founded in Paris at the moment of Tristan Tzara's first public lecture in 1919, there was a "proto-Dadaist" movement already established. Taken as a unit and to momentarily ignore their differences, they maintained the idea of "a permanent revolt of the individual against art, against morality, against society." In the words of art historian and curator William Rubin, both Dadaism and Surrealism were heirs to something much broader, "a kind of creative activity already in the air" since about 1912.

The parallels and the divergences, which make a clear history so difficult to trace, were demonstrated at the 1917 performance of Apollinaire's play *Les Mamelles de Tirésias* ("The Breasts of Tiresias"), a farce already designed in the best of the avant-garde tradition to shock and provoke the sensibilities of the middle class. By this time Guillaume Apollinaire was one of the most important French poets and art critics of the early twentieth century. Serving and becoming wounded in the war, he had been the first to champion the work of emerging artists like Picasso and Matisse, was a friend of the Futurists, and was in fact the first to coin the word "surrealist," which appeared as the subtitle to his play.

Yet the opening was "one-upped" by Jacques Vaché, who, excited by the play, began waving a pistol. Threatening to fire it into the audience, he had to be forcibly stopped. This was a dada event before Dada, but equally significant is that the same "gesture" had been made several years earlier by Cravan—who had so insulted modern artists and Apollinaire that the latter challenged him to a duel. Breton, appropriating the story years later, used it unattributed to describe what it meant to possess a Surrealist sensibility.

From Dada to Surrealism

The group of young poets around *Littérature* aligned themselves with Dadaism by mid-1920 and participated in Dada manifestations or soirées and wrote Dada declarations—just as the movement imploded. Picabia publicly declared Dada dead in 1921 and attacked other Dadaists in 1922, including Tzara, because it had become too organized a movement. For the opposite reason, in 1922 Breton called for an international conference to lay out a program for the "modern spirit," a concept widely shared and variously defined across Paris at this time. Dada had brought them to this point but something more lucid, programmatic, and progressive was now needed. This departure from the anarchism of Dada marks the beginnings of Surrealism.

The conference was rejected publicly by many of the Dadaists, who called Breton to task for insulting them and Tzara. In revenge, Breton waylaid Tristan Tzara in public during a 1923 performance. A full-scale riot ensued and police action was brought against Breton. The lines were finally drawn and many have presented that night as the passing of leadership from Tzara to Breton. The word "surrealism" had been appropriated from Apollinaire, who never defined it, and put into circulation during 1921–23, as Breton and his colleagues began "crystallizing" the tenets of the movement. In October of 1924 Breton published his manifesto.

The Meaning of Breton's Surrealism

In the first manifesto Breton pointedly declared his definition of Surrealism to be different from that of Apollinaire's. What Breton ignored was the faction of more radical Dadaists who had already rejected Apollinaire and his love of art as too conservative. Breton's real genius was that of a politician. He laid claim to positions both more radical, like Vaché, and more conservative, like Apollinaire, while ignoring his own differences with them. He felt his program for art differed from both positions and as a good promoter he knew one must herald newness rather than synthesis. Nevertheless, an important part of the Surrealist movement would always side with the more radical position and suspect "art" work as irrelevant; even Breton would argue against art in its traditional meaning.

Breton declared "surrealism" a "new mode of pure expression" and admitted they could have used the word supernaturalism just as easily. But he wanted a special sense of the word:

SURREALISM, n. Psychic automatism in its pure state, by which we propose to express—verbally, in writing, or in any other manner—the real process of thought. The dictation of thought, in the absence of any control exercised by reason and outside any aesthetic or moral concerns.

ENCYCLOPEDIA. *Philosophy.* Surrealism is based on the belief in the superior reality of certain forms of previously neglected associations, in the omnipotence of the dream, in the disinterested play of thought. It tends to destroy definitively all other psychic mechanisms and to substitute itself for them in solving all the principle problems of life.

The definition was followed by Breton's list of writers and poets, essentially members of his own circle, who had already "performed acts of Absolute Surrealism." And immediately Breton began his lifelong cultural archaeology by listing those now past who could pass for Surrealists: Dante, Baudelaire, Rimbaud, Mallarmé, Vaché, Poe, among others. However, these men could never be

The False Mirror

RENÉ MAGRITTE; *1928; oil on canvas; 21¼ x 31⅞ in.*
(54 x 80.9 cm). The Museum of Modern Art, New York.
The image of the closed eye became a secret sign among Surrealists for the subversion of reality by drawing on interior states. Thus the image of the open eye, ordinarily interpreted as access between the individual and the world, was a false vision or mirror. Reality lay elsewhere.

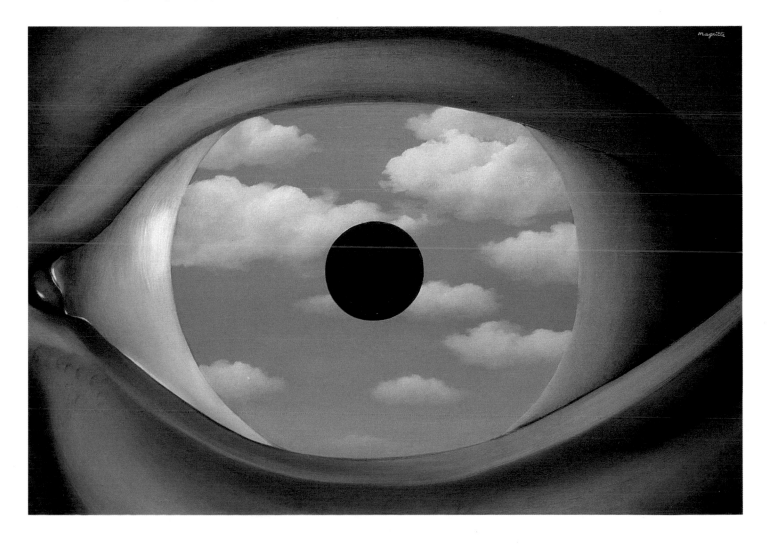

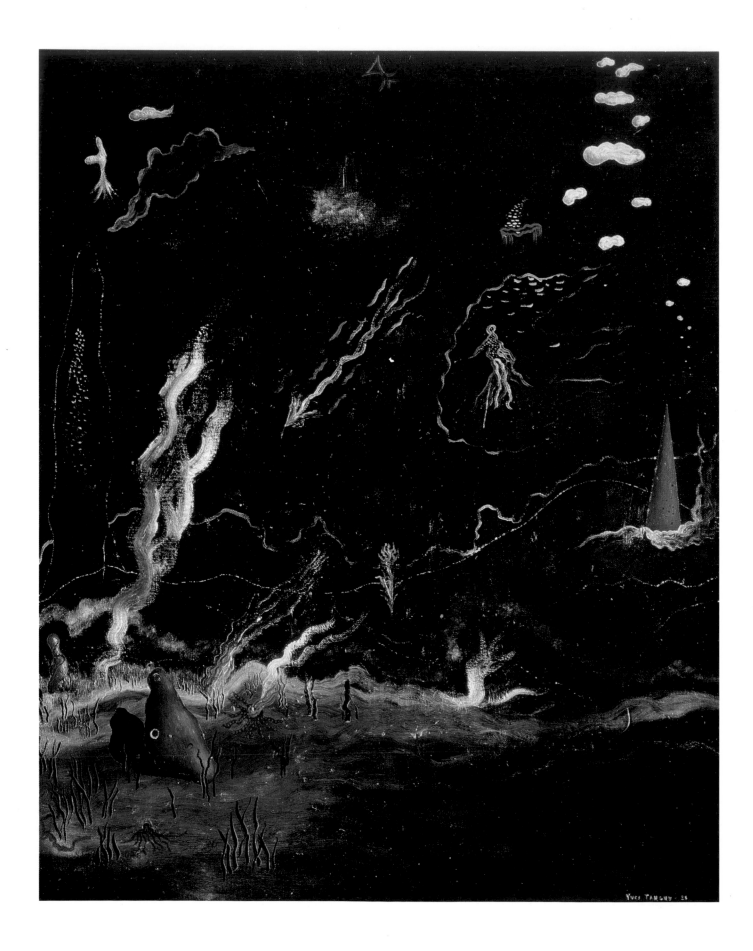

Surrealists at all times because they suffered from "preconceived ideas." Their great talents were, Breton suggests, perhaps lessened because they filtered their works in order to produce them. True Surrealists have no talent, he argued, thus they need no filters; they are able ideally to speak their own thoughts just as they have them. In fact, the best Surrealist is one who never stops long enough to record words at all since that would undo the pure "state," or channel that Breton demands in the identity of Surrealism. This means, as Breton would later try to show, that virtually anyone can be a Surrealist, if and when they develop this clear channel between thought and act. Indeed, the manifesto taken as a whole is an argument for the removal of those blocks, an argument to liberate human creativity in its fullest capacity.

The first manifesto argued for a poetic and not a visual form of Surrealism. Following the lead of the European avant-garde in general, Breton argued Surrealism as an aesthetics of liberation. He inverted the original Dada conception of life as insane to life as overly rationalized, but his solution differed only in degree. Both movements held faith in the creative act and moment, insisting on absolute freedom and on the site of art as the mind rather than in its physical form. The major difference was Breton's insistence on a systematic program and his public address to an audience over time. The Dada moment was an act not meant to survive; the audience could participate but merely in the carnage of the moment. The Surrealists claimed a concern for permanent change, or, to take a page from Leon Trotsky, the Russian political theorist later supported by Breton, the Surrealists wanted to establish a "permanent revolution." To sustain the concept of moment to moment revolution was their ultimate dream.

The Storm

Yves Tanguy; *1926; oil on canvas; 32 x 25¼ in. (81.2 x 65.4 cm).*

The Louise and Walter Arensberg Collection, Philadelphia Museum of Art.

Tanguy's early works created a habitat for abstraction, a place where dismembered elements of form took on a sense of life, appearing to be at home in a primordial soup.

The Psychoanalytic—My Way

A major point of separation between Dadaism and Surrealism was the Surrealists' enthusiastic embrace of the ideas of Sigmund Freud. Breton had studied medicine, served as an orderly in an army mental clinic during the war, and, in 1921, paid homage to Freud with a visit. Freud was flattered by the artists' professed belief in his work, especially since so little of it had reached France in translation, but overall the meeting was a bit of a disaster as Breton left without Freud's support. Freud considered the realm of the unconscious to be inaccessible except through the indirect method of dream analysis and apparently random associations. To him, easy or even direct access to the unconscious was impossible.

The influence of Freudian psychology was crucial and it is imbedded in the basic understanding and work of the Surrealist movement. But in reading Breton we are struck by his lack of particulars regarding psychology or Freud. He raised the issue of psychology in his 1924 manifesto as an area that provides an alternative to "living under the reign of logic" where only logical methods of description and analysis are applied to solving problems. Sounding more like a romantic symbolist from the late nineteenth century than a true modern supposedly knowledgeable in psychology, he argued the significance of fancy, imagination, and superstition.

Apparently what he had learned from Freud, whose name and general orientation to the importance of dreams he publicly praises, was simply that there were "strange forces" below the surface of our waking state, important forces we rarely admit into normal consciousness, and the key to them lies in the state of dreaming. He observed that not even the "analysts" have worked out all the means of investigation and application of this knowledge. And, in what is likely a veiled reference to his rebuff by Freud, Breton proclaims that this area can now be "the provinces of the poet as well as the scholar."

Breton did provide a powerful argument for the authority of artists and their creativity: They now equal the scientists, the Surrealists declared, and can lead the exploration into new areas and methods of investigation.

Automatism

Automatism, which is the free flow of associations, was to be the process or state of mental existence whereby control of reason was purposefully lost in favor of "the real process of thought." Most interpreters of Surrealism have accepted Breton's assertion that "pure psychic automatism" was the single most important principle of Surrealism. The Dadaists had spoken for the abolition of rationality and logic in favor of new art processes and forms developed through chance and irrational association. For the Surrealists, chance remained a valid external force, but because of their interest in psychiatry the automatic was equated with the unconscious in all its manifestations.

In 1922 Breton wrote specifically of this state of psychic automatism as "a near equivalent to the dream state," a place where one could hear the "murmur" of the "unconscious." In 1919 he had recognized that fragmentary sentences emerged from unknown origins into his conscious perception when his mind was "in total solitude, when sleep is near." These fragments were "first-rate poetic material," and he and others began to contemplate how to induce such material into existence voluntarily.

At first he and Soupault practiced a purposeful forgetfulness of the outside world which produced their first "automatic" book in 1920, *Les Champs magnétiques* ("Magnetic Fields"), written in daily and disconnected fragments that Breton called "magical dictation." From this they moved to "periods of sleep," which was their form of the trance state mediums used when contacting spirits. The process was

Bison on the Brink of a Chasm

ANDRÉ MASSON; *1944; brush and ink on paper; 31⅛ x 22⅝ in. (79 x 57.6 cm). Gift of Joseph H. Hirshhorn, 1966, Hirshhorn Museum and Sculpture Garden, Smithsonian Institution, Washington, D.C.*

Few were as adept at the transformations of automatic drawing as Masson, prompting Breton to praise him with Goethe's phrase, "What is within is also without."

One (Number 31, 1950)

JACKSON POLLOCK; *1950; oil and enamel on unprimed canvas; 106 x 209⅝ in. (269.5 x 530.8 cm). Sidney and Harriet Janis Collection Fund (by exchange), The Museum of Modern Art, New York.*

The automatism of Surrealism and a belief in primal psychic forces are at the fore in Pollock's mature style, which shifts away from the earlier, more raw mythology of Masson and the Surrealists.

successful to varying degrees, depending upon the individuals involved. Robert Desnos was the most extreme in his ability to speak in poetic Alexandrines, twelve-syllable phrases correctly accented in rhyme, while "asleep." Hypnosis, a technique generally rejected by Freud, was used extensively with many of the results transcribed and published. The experiments among the Surrealist poets in hypnotic sleep were a general attempt to implement Freud's ideas and link them to the process of creativity, to open the doors of psychic perception. However, the Surrealists ignored the diagnostic and therapeutic particulars of psychoanalysis to create a synthesis that served their own ends and belief in poetic production.

Poets concentrated on speaking and writing automatically, i.e., by means which bypassed rational control. Some editing would occur after the fact. Visual artists such as André Masson sometimes used the same technique, premise, and editing. Masson's 1944 pen and ink drawing *Bison on the Brink of a Chasm* is one of many produced by a process of "automatic" drawing. The title seems to make an oblique reference to life lived in this state—as one may on the brink of a chasm. Both writers and visual artists also developed a number of other techniques to bypass control. Many, like Max Ernst, relied too on the principle of chance as developed in Dada.

Games, especially word games, and gamesmanship were popular among all the Surrealists for reasons of chance. Marcel Duchamp, Francis Picabia, and the New York circle of patrons were major exponents of such gaming well before the advent of Surrealism. Perhaps the best known Surrealist game was the one titled "exquisite corpse" (*cadavres exquis*), developed in 1925. Like many of their games it was designed for group participation and relied on the chance encounter as a disruption of rationality and a product of the shared, oceanic unconscious in which the Surrealists believed. Each player would write a word on a section of paper, then fold it so the next player could not see what had been created. The next player had to add to it. The game began with words but was immediately adapted to images or combinations of words and images.

Many a Surrealist painting was born from the juxtaposition of such disjunctive images. A phrase—celebrated among Surrealists—borrowed from the nineteenth-century Symbolist poet Lautréamont (Isidore Ducasse) summarized the desire for an entire aesthetic based on

Exquisite Corpse

ANDRÉ BRETON, TRISTAN TZARA,
VALENTINE HUGO, GRETA KNUTSEN;

c. 1933; composite drawing:
colored chalk on black paper;
9 x 12 in. (24.1 x 31.7 cm).
The Museum of Modern Art, New York.

Exquisite Corpse was the
most famous of several games
developed by the Surrealists.
It was a strategy of chance used
to generate disjunctive images
from collective participation.

disjunction and displacement: "The chance encounter of a sewing machine and umbrella on an ironing board." The image seemingly makes no sense and is the more frustrating or disjunctive simply because it decontextualizes normal objects in the world. Their reliance on elements of disjunction and displacement, first developed with Cubist collage of 1912, then modified by the Dadaists, had intriguing parallels to many of Freud's theories of psychological mechanisms. It also led to the marvelous.

The Marvelous

Introduced in the first manifesto, the concept of the marvelous grew in importance if not in clarity for Breton over the years. Scholar of Surrealism Hal Foster has argued that the marvelous eventually replaced

The Great Masturbator

SALVADOR DALÍ; *1929; oil on canvas; 43 x 58¾ in. (110 x 150.5 cm). Fundacion Gala–Salvador Dalí, Figueras.* The Great Masturbator became an independent character in Dalí's paintings and writings. The central image of the profile head is that of Dalí; the closed eyes place the figure in the unconscious. The grasshopper is a self-referential representation of a displaced childhood fear of being eaten, a sublimated fear allied to sex.

automatism as the basic principle of Surrealism. The 1924 understanding of Surrealism was defined as a resolution of the states of dream and reality into "a sort of absolute reality, a *surreality*." This rare state, one considered natural in children before they are weaned from it, Breton calls by another name—the marvelous.

As the Surrealists came to value more greatly internal necessity or compulsion over choice, the marvelous became a state of possession. It visited you or you sensed its possession of another. The marvelous and beauty could now be restricted to that which was compulsive.

The Crisis in Consciousness: Politics & Mysticism

Politics, from a Dadaist viewpoint, was simply one more rational system contributing to the general cultural insanity and thus to be rejected. There was to be liberation, but for the individual soul and moment. The Surrealists began with a Dada-like position, then developed a more systematic and engaged attitude to politics. But also typical of the Surrealists, everything was filtered through Breton and his own desire to maintain a coherent movement, even if it meant equivocation in the face of demands for resoluteness.

From automatism, a liberation in physical fact was assumed to follow. This claim has been made by many avant-garde movements and often remains the case today. Few movements supported direct or overt alliances with politics. This was certainly the position of the Surrealists until about 1929. Their first consistent journal, *La Révolution surrealiste* ("Surrealist Revolution"), published from 1924 until 1929, was in sympathy with the political left, especially the Russian Revolution carried off under the banner of Marxism, but not its overt action. By 1929 their position became a self-proclaimed "crisis of consciousness."

The relation between art for itself (what Ernst called the pursuit of pure Surrealist activity) and politics was precipitated by personal battles of power, French injustices against indigenous peoples in Morocco, and Joseph Stalin's 1929 exile of the Russian revolutionist and writer Leon Trotsky, whom Breton greatly admired. In a conference called in 1930 by Breton to form a unified response, the many factions broke with his leadership. This led to a second manifesto for Surrealism and a purification of the movement, with Breton excommunicating those who held positions different from his own. But, as usual, his

position was equivocal and ignored its own contradictions. Of course, as he clearly noted, a good Surrealist knows no contradictions.

In 1929 Breton attacked the move of colleagues into direct alignment with the Communist Party. Then he exiled some of those who believed too strongly in art for its own sake and aligned the movement with the French Communist Party—only to move Surrealism away from it by 1934. The Second Manifesto in 1929 distanced itself from automatism and discussed the inadequacies of dreams. Surrealism would no longer use art for an "alibi" but push toward a philosophy of political commitment. The new journal would not be simply the "Surrealist Revolution" but now, in 1930, labeled "Surrealism in the Service of the Revolution" (*Le Surréalisme au service de la révolution*). Yet at the same time Breton introduced the "occult," adopted the language of alchemy, and endorsed a mystical stance, all of which are antithetical to direct political action. This, however, did set the tone for later Surrealism to explore the mystery of the unseen, and of the strange, uncanny power of inanimate objects. Also at this time Louis Aragon, speaking for the Breton wing, publicly introduced the importance of love for the Surrealists.

Breton's authoritarian tactics and equivocations were met by published counter-attacks of him as a "false revolutionary" and a second group of Surrealists, aligned with Michel Leiris and Georges Bataille, among others, split off. Breton had already attacked Bataille with great venom for supporting extreme concepts which Breton considered pathological, separating them from an overriding ethics. Later, the Bataille circle of Surrealism was to produce some of the most dramatic and controversial forms whose "limits" remain a debated topic today. Overall, the ranks of the Surrealist movement were pruned, but simultaneously several new and important members joined up as the life of Surrealism entered a second, more international phase.

Spoon Woman

ALBERTO GIACOMETTI; *1926–27; bronze;*
height 57 in. (144.7 cm). The Solomon R. Guggenheim Museum, New York.
One of the few to emerge as a major sculptor in Surrealism,
Giacometti created a primitive totem in his early attempt
to render the presence of a figure through an abstract form.

CHAPTER FOUR

THE INTERNATIONALIZATION OF SURREALISM

The internationalization of the Surrealist movement is dated after the purges and schisms surrounding 1929's Second Surrealist Manifesto, acknowledging the new membership in the early 1930s and the spread of ideas and exhibition schedules into the 1940s and '50s. Their diaspora during World War II had a profound effect on the culture of art and eventually there were hundreds of claimed members with Surrealist chapters or organizations in most major European capitals, as well as in South and North America. But Surrealism had been international from the beginning, forged from the international Dada movement. Many of the original artists from the 1920s continued to be aligned, formally or informally, with the Surrealists, and ideas continued to develop in the so-called heroic period of 1924–29. Old or new, they shared the desire to shift avant-garde art from pure-painting (*peinture-pure*) to poetic-painting (*peinture-poésie*).

Max Ernst

As the group moved to differentiate itself from Dadaism it was Max Ernst, newly arrived in Paris from Cologne in

The Elephant Celebes

MAX ERNST; *1921; oil on canvas; 51⅛ x 43 in. (129.8 x 110.4 cm). Tate Gallery, London.*
Paintings such as these show how artificial the line is between Dadaism and Surrealism. It is likely that the poet-formulators of Surrealism learned a great deal about their own future directions from reading Ernst's paintings, prints, and collages.

1922, who was working with the issues that interested them most. Before teaching himself painting, Ernst had been a student of both philosophy and psychiatry, studied the works of Jean Charcot and Freud, and visited an asylum to witness the power of images created by those judged insane. Much of his painting constituted an unwritten manifesto with which Breton apparently collaborated.

Ernst's *The Elephant Celebes* (1921) signals the new influence of de Chirico in synthesis with his established use of collage. Ernst had been collaging images from his own hypnagogic state, as well as images found in the ordinary world of journals and magazines which had some psychic resonance for him. In this work he has "found" a de Chirico mannequin, and removed the head—hence the sight of the figure—while allowing it to "see" well enough to beckon the large biomechanical form in the background, another "found" image. The collaged disjunction makes little apparent sense, thus the non-sense of Dada. But the issue of sightless sight was an important one for the Surrealists since it stood as a metaphor for the higher internal vision. A similar metaphor runs throughout the slightly later work of the Belgian Surrealist René Magritte, as seen in his 1928 painting of an open eye, *The False Mirror*. Open eyes see the wrong world; only sightless sight may truly see and beckon others.

Ernst's *Two Children Are Threatened by a Nightingale* (1924) extends the idea of collage into physical construction. The distant vista owes a debt to de Chirico,

69

Untitled

OSCAR DOMÍNGUEZ; *1936;*
gouache transfer (decalcomania)
on paper; 14⅛ x 11 in. (35.9 x 29.2 cm).
The Museum of Modern Art, New York.
Domínguez is credited with
the invention of decalcomania
(in 1935) as a technique to
develop images through chance
occurrences. Laying one piece
of paper on another with a
wet medium resulted in an
abstract image that gave an
untouched spontaneity to the
suggestion of a primal nature.

and the use of infinite space as a metaphor for mental or psychical space was utilized by an entire wing of Surrealist illusionist painters: Salvador Dalí, Magritte, Paul Delvaux, Yves Tanguy, Kay Sage, Dorothea Tanning, and Lenora Carrington, among others. Here Ernst uses a bird—a frequent symbol in his work—placed typically in a mysterious and unnerving spatial theater on whose stage an enigmatic psychic drama plays out. There was no difference for Ernst between the dream and reality, a condition that made him a lifelong model for Surrealism and Breton.

Ernst's lack of formal training may be the reason he was the least bound and most innovative of the Surrealists in applying new techniques, which he always placed in the service of the imagination. In 1925 he began to use rubbings ("frottage"), where he acquired an image from laying paper over a textured surface and rubbing it with pencil or crayon. For instance, his oil painting *The Horde* (1927) used frottage from rubbings of strings for an accidental discovery in the world of monsters, enhanced to show their simultaneous existence in reality and in our unconscious.

Later, Ernst often applied these powers to a critique of Western civilization. *Europe After the Rain* (1940–42) portrays the carnage of a Europe at war. The process used here was decalcomania, a technique "invented" by the Spanish Surrealist Oscar Dominguez in 1934, later employed by many artists. Similar to frottage, the image results accidentally from laying one sheet on another which already contains oil or some other wet medium. Dominguez and others were content with their amorphous images, which were a veritable fantasy of abstract

forms suggesting minerals, fauna, aquatic life, and luxuriant growth. Ernst, however, mined these tellurian hills with his own hallucinatory vision.

Chance operated as a concrete and integral part of Surrealist process, a form they termed "objective chance." Here visions are found already concretized in the world rather than created from within the artist and positioned into the world, as would be the case with automatism. The resonance between the interior state of the artist and the exterior condition of nature was taken as testimony to the marvelous.

Joan Miró

Surrealism gave the Spanish painter Joan Miró (1893–1983) the confidence to go back into the roots of his life and draw from them a rich amalgam of imagery and fantasy. Like his close friend and fellow traveler in the development of an abstract form of Surrealism, André Masson, Miró converted the shallow space of Cubism into a kind of mental laboratory. There, he loosed his automatism to create biomorphic forms which inhabit that most Surrealist of sites, the region that partakes of both reality and dream. *The Harlequin's Carnival* (1924–25) invokes

the richness of a childhood imagination—a literal carnival of doll-like masqueraders cavorting in the animated workshop-studio of their creator. The combination of children's fantasy and the deeper psychological resonance derived from these biomorphic forms touch us as we both witness and participate.

Not given to argument or interest in the politics and theory that preoccupied the Surrealists in the early 1930s, Miró drifted away from the official movement while retaining contact, relationships, and collaborations. He also continued his own, highly personal development which oscillated between the imagery of the fantastic and that of pure abstraction. In 1925 he began to work less realistically and more automatically, deriving images from his paint on the canvas. Finally, in synthesis, he began with found images in the world—such as animals and machine parts—and transformed them into abstract biomorphs reminiscent of Arp. His series of paintings from the early 1930s portray biomorphs that seem somehow alive, floating in an infinite space. For Miró, the process of transformation, now hidden from the viewer, embodied the Surrealist relationship between the real and poetic worlds.

Europe After the Rain

MAX ERNST; 1940–42; oil on canvas; 21 x 58⅛ in.
(54.6 x 147.6 cm). The Ella Gallup Sumner and Mary Catlin Sumner
Collection Fund, Wadsworth Atheneum, Hartford, Connecticut.
This painting, begun in Europe and finished in the United States, is one of Ernst's first using the technique of decalcomania. The organic horror that emerges is often read as an interpretation of the bombings in Europe during World War II.

FOLLOWING PAGE:

The Harlequin's Carnival

JOAN MIRÓ; 1924–25; oil on canvas; 26 x 36⅝ in. (66 x 91.4 cm).
Contemporary Art Fund, 1940, Albright-Knox Art Gallery, Buffalo, New York.
Miró's ability to give himself up entirely to the recreation of a new and private world through painting brought Breton to call him "the most Surrealist of us all."

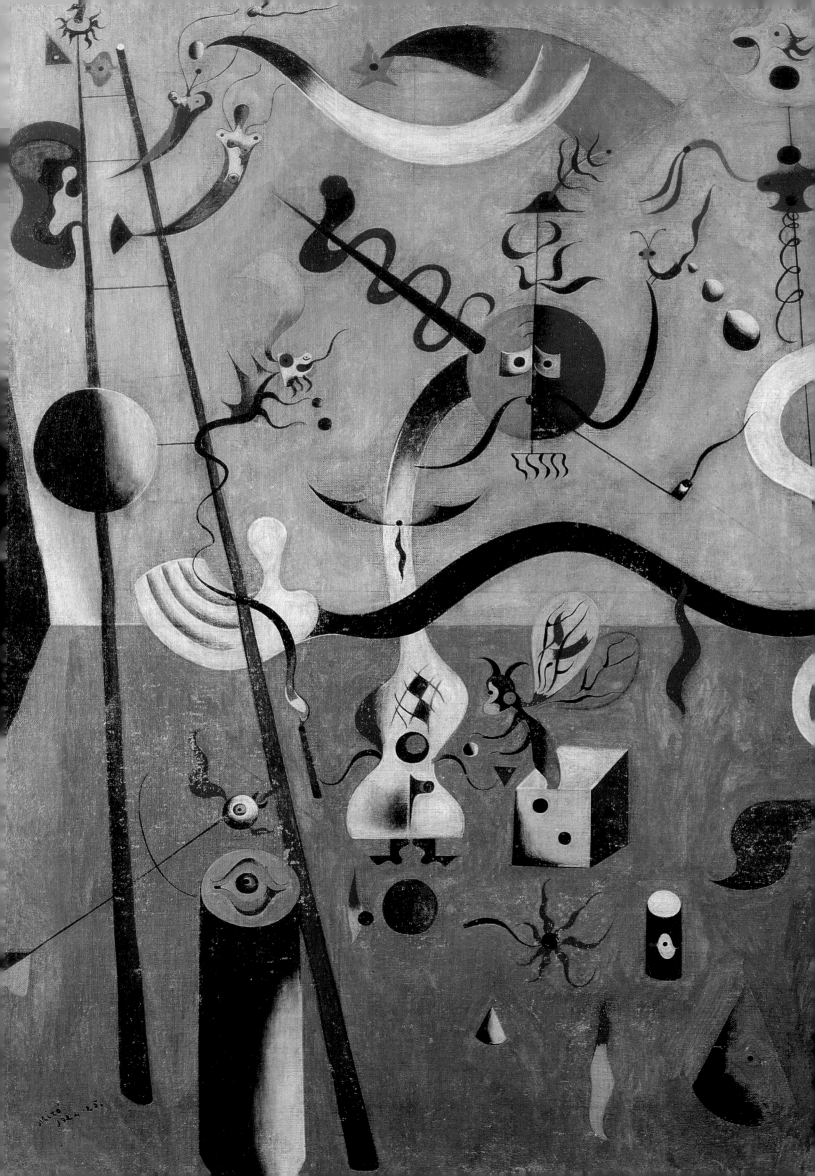

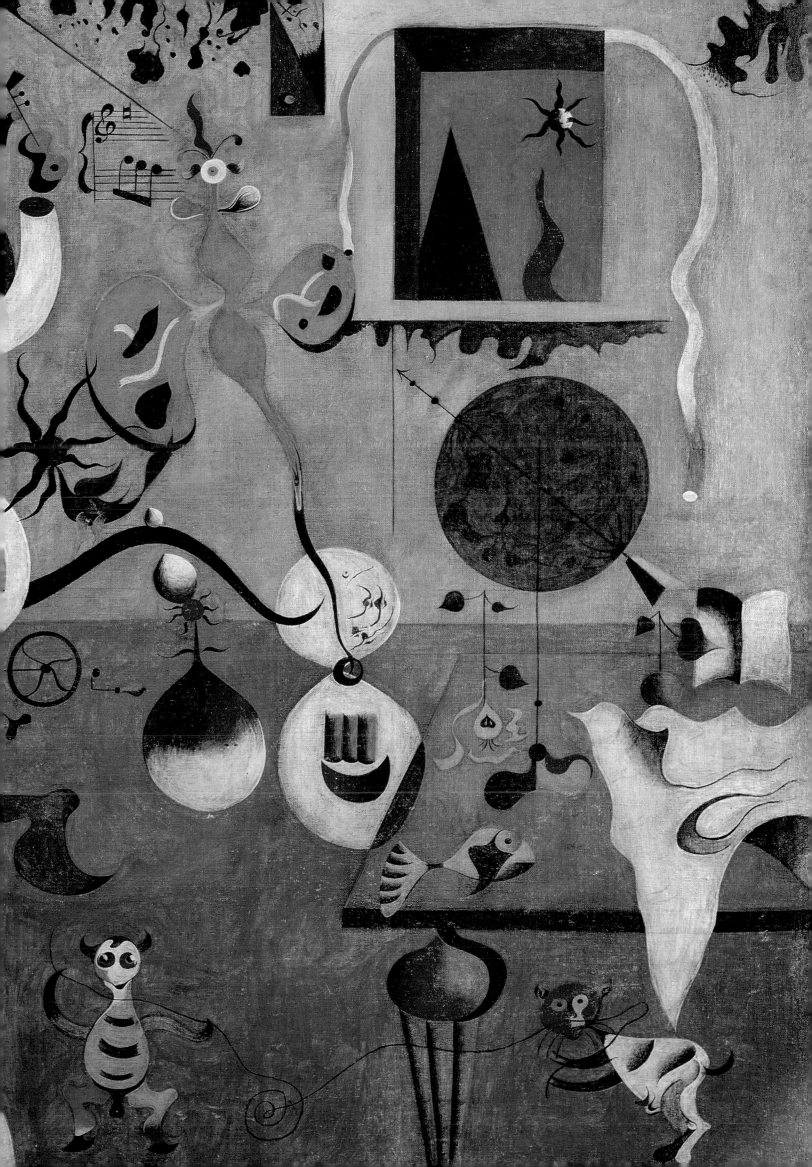

André Masson

The abstract automatist art practiced by Arp, Miró, and Masson was the dominant form of art in the 1920s and into the early 1930s. Masson (1896–1987) consistently worked with the automatic processes as never ending sources for images. Wounded and traumatized by the trench fighting in World War I, his images and titles eventually embodied a mythological world of primal passion and conflagration. His *Battle of Fishes* (1926) pictured the world as the battleground of the oceanic unconscious, where blood is figuratively spilled across real sand.

Excommunicated by Breton but reconciled in the late 1930s, Masson was allied more with the Bataille group of Surrealists. His work developed an open eroticism, one of forces more than forms. Masson was among the many who came to the United States during the war years. His continued use of mythological figures, such as in *There is No Finished World* (1942), reference both ancient monsters and the primal unconscious—a point of interest that members of the New York School of Abstract Expressionists found significant. In the 1940s they, too, were trying to develop a sense of the primal power found in mythology but located in some alternative to European traditions, an alternative indicated for them by Masson's images and belief in automatic creative processes.

Magritte & Tanguy

The other major pole to Surrealist painting consisted of an almost academic style utilizing clear contours and forms designed to convince the viewer of their three-dimensional reality. Their sense of illusionism, however, was part of a Surrealist agenda to present the tangibility of the unreal. Artists such as René Magritte, Yves Tanguy, Salvador Dalí, and many more, presented images in a highly realistic style to establish a purposeful contradiction—a believable presentation of unreal images.

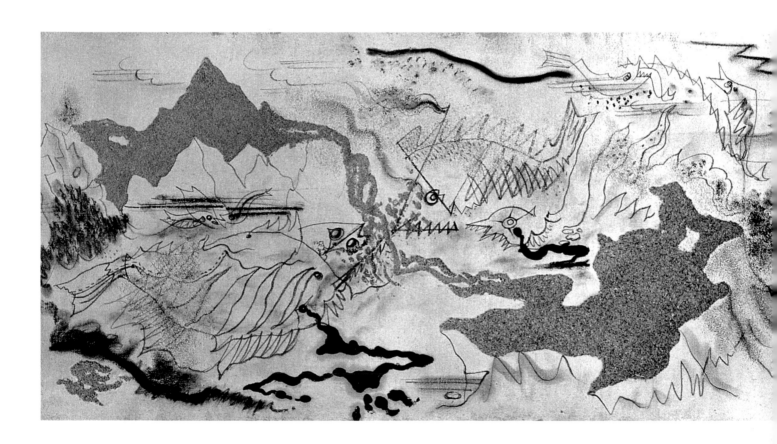

Battle of Fishes

ANDRÉ MASSON; *1926; sand, gesso, oil, pencil, and charcoal on canvas; 14¼ x 28¾ in. (36.2 x 73 cm). The Museum of Modern Art, New York.*

Masson developed a personal mythology throughout his life, frequently using the automatic dripping of glue covered with sand as a source for his images. His world was one filled with the hostility and battles of primal forces in conflict.

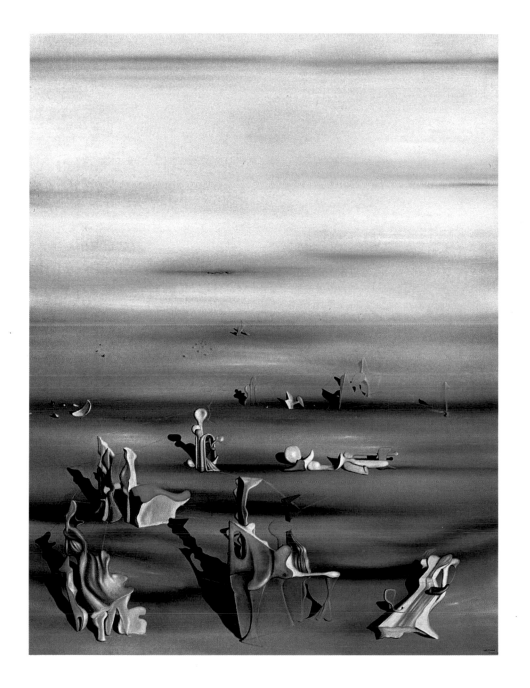

The Furniture of Time

YVES TANGUY; *1939; oil on canvas;*
46 x 35¼ in. (116.7 x 89.4 cm).
James Thrall Soby bequest,
The Museum of Modern Art, New York.
Influenced, like Magritte, by the
spatial settings of de Chirico,
Tanguy merged his abstract
objects with the setting,
relying less on disjunction
and more on absorption.

Starting, like Ernst, from the works of de Chirico, the Belgian painter René Magritte (1898–1967) remained committed to creating recognizable images, though ones designed to question the nature of images and imaging. In pitting "illusionistic" against "real" space, he reminds us that this is, after all, painting. For instance, *The Promenades of Euclid* (1955) is a late version of a lifelong theme: how painting is assumed to be a spatial extension of this world. With his incredible spatial illusion and reference system, Magritte offers painting as an extension of the dream or the marvelous in the world. In short, he is able to use traditional systems to give a new function to painting. His few paintings that combine words and images also rely on confounding the relationship between systems of seeing and knowing.

The French painter Yves Tanguy (1900–55) turned to painting after seeing a de Chirico in a window. Self-taught, his early works have a loose, airy quality to them, as evidenced in *The Storm* (1926), whose lush grottolike setting has fragmentary images embedded like floating bits of irrational mental debris. By 1927 Tanguy began construction of deep spatial settings populated with tightly painted biomorphic forms, a typology he followed for the rest of his life and can be seen in *The Furniture of Time* (1929). Unlike Arp and Miró, Tanguy's forms carry no overtones of narration or literalness. His sense of the poetic comes not from the forms themselves but rather from the way they are embedded within a deep, atmospheric space.

Still from the film *An Andalusian Dog (Un Chien Andalou)*

SALVADOR DALÍ AND LUIS BUÑUEL; *The Kobal Collection, New York.*

In the most shocking opening of any movie, a razor cuts through the eye of a woman. Psychoanalytic readings have discussed this as castration or defloration, but the motif may also come from a painting by Max Ernst in which the pierced eye stands for a true, inward vision.

Salvador Dalí

Salvador Dalí (1904–89) was one of the important new members heralding the 1930s expansion of Surrealism. He and fellow Spanish filmmaker Luis Buñuel had been directly influenced by the movement while making, in 1929, their renowned art film *Un chien Andalou* ("An Andalusian Dog"), followed in 1930 by *L'Age d'or* ("The Golden Age"). The Surrealists were avid film fans and the magic fantasy of the bright screen in the dark room gave an invigorating metaphor for their own program. But aside from a few examples, in the 1930s Surrealist film as a genre awaited Buñuel's further development in the 1950s. The early works were generally a compendium of visual scenes, often unrelated or arranged along a broad theme and derived from Dada films. But their emphasis on the issues of desire and its psychological burdens or, more pointedly, on the outrageous erotics of love in the face of middle-class restrictions, were pure Surrealism.

It is Dalí more than any figure in the public eye who has come to embody Surrealism in art, act, and even appearance, all testimony to his true genius—publicity. Aside from his personality, Dalí is best known for his realistic style of painting images which are recognizable but generally resistant to rational interpretation. The combination is disruptive and provides a surreal moment of interplay between the reconcilable and the irreconcilable, between a base in reality and a dreamscape. In this Dalí is one of many, but he is certainly one of the best physical and academic painters of the group, and his work is more consistently outrageous, matching exactly his public persona and distinctive philosophy.

Dalí's introduction to Freudianism through the Surrealists solidified a lifelong personal struggle with a powerful dream world and allowed him to accept more openly the erotics and anxieties he found there. Dalí rejected the "sleep" of the Surrealists to produce art from an agitated psychological state of self-induced paranoia, a process he called a "paranoiac-critical activity." This he first defined as a "spontaneous method of irrational knowledge based upon the critical and systematic objectification of delirious associations and interpretations."

Early paintings such as *Illumined Pleasures* and *The Great Masturbator*, both from 1929, are typical small-sized paintings of images that seem to be solidified dreams set within the Surrealist infinite space. Highly realistic in style, portraying what appear to be unreal images, they are actually "real" embodiments of not just Dalí's own fantasies but of the psychological, and often psychosexual, issues which many deny or wish to avoid. Although Freud, whom Dalí met in 1938, chastised the artist for his conscious rather than unconscious imagery, Dalí's art does resonate on a personal level to reinforce public communication. His *Soft Construction with Boiled Beans: Premonition of Civil War* (1936) embodies the horror of the Spanish Civil War. The evocation of monstrosity is made powerful precisely because the artist uses the biomorphic organicism of the boiled bean to elicit a primal sexuality which resonates on a personal level. The open phallicism, implied castration, and impotence marshal his personal male fears through a blatant but shocking Freudian understanding into a history painting.

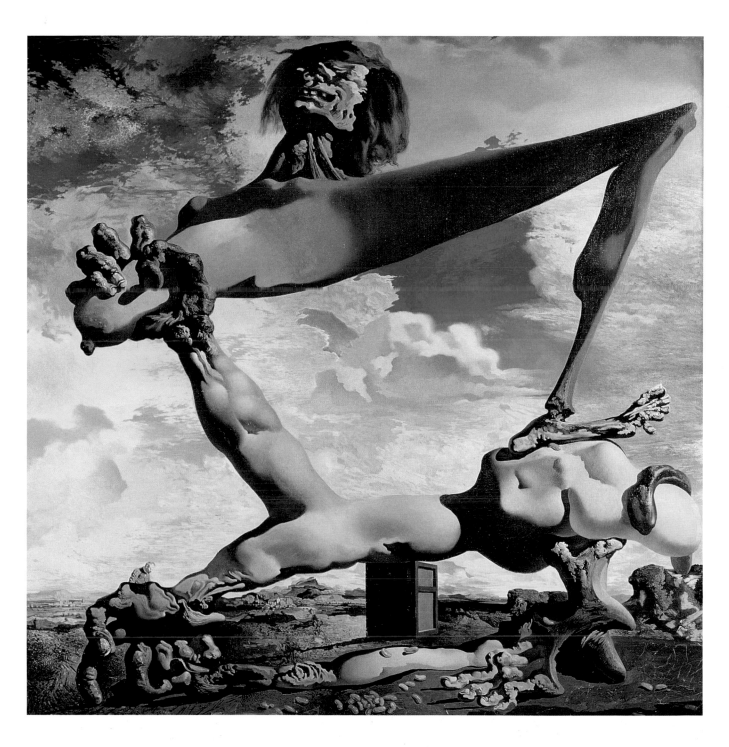

Expelled by Breton in 1934 for his commercialism, Dalí moved to the United States in 1940 to participate in its commercial culture. By 1950 he turned to Christian and mystical subject matter—such as *The Sacrament of the Last Supper* (1955)—works whose stature in the history of art is still the subject of much debate. These late works, though, do remind us that although Dalí's paintings often assert a psychological alienation, there is at the root of his art, as with many Surrealist artists, a desire to communicate a fuller sense of life.

Soft Construction with Boiled Beans: Premonition of Civil War

SALVADOR DALI; *1936; oil on canvas; 39 x 38 in.*
(100 x 99 cm). Philadelphia Museum of Art.
Dalí's private repressions and dreams could be marshaled into a powerful account of public issues, as in this painting devoted to the Spanish Civil War.

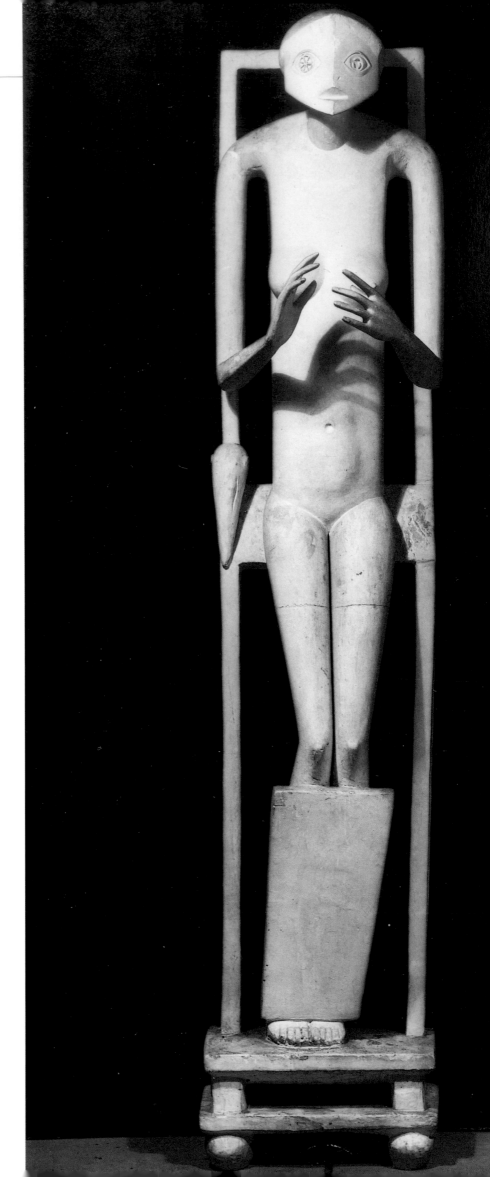

Hands Holding the Void (Invisible Objects)

ALBERTO GIACOMETTI;
1934–35; plaster;
height 61 in. (156.2 cm).
Anonymous gift,
Yale University Art Gallery,
New Haven, Connecticut.
Breton devoted more
writing to this work,
his last piece of
Surrealist sculpture,
than any other piece
of sculpture, as he
watched its making
in the studio. Ignoring
its sources and full
meaning, Breton
discussed it in terms
of love and the pre-
sence of the invisible.

Giacometti & the Unseen

The Swiss sculptor Alberto Giacometti's (1901–66) bronze "figure" *Spoon Woman* (1926–27) illustrates the application of a modernist simplification of form to a highly personalized and playful use of African wood carving. The combination of woman and spoon, produced several years before Giacometti joined the Surrealists, was the type of disjunction and visual metamorphosis that appealed to their aesthetic.

His 1932 cast bronze floor piece, *Woman with Her Throat Cut*, confronts us uncomfortably with the problematic aspects of violence and sexuality within the heterosexual and primarily patriarchal orientation of Surrealism. True, the figure is more insect than woman, a type of anthropomorphizing revered by many Surrealists, and it is more thorax than throat that has been cut. But the title moves us purposefully to "woman" and the death throes are cannibalized into a fairly blatant psychosexual eros typical in sadism. Biological sexual instincts are, of course, at the base of Freud's theory of the psyche and served the Surrealists as a metaphor for creativity in addition to being another way to shock the middle class. However, a work like this brings more than sexual drive and creativity to the foreground.

The debate, like that over the libertine French author Marquis de Sade, the mentor of much of the later Bataille wing of Surrealism, is not resolved even today. It is maintained between those who interpret such images as testimonials to a blatant misogyny in much of Surrealism and others who see them as constructs to confront the public with its uncomfortable truths. The doll constructions (*La Poupée*), which are Freudian fetish-objects, and the drawings and photographs of them by the German Surrealist Hans Bellmer, place this question directly: What are the problems and the consequences of latent sexual fantasy now made manifest? Most Western cultures wrestle unevenly with the issue of the repressed, though public interpretations often differ from the intentions of the artist. The latter also raises a question central to much of modern art—the strategies, role, and function of consciousness-raising by intellectuals. Dreams of liberation, sexual or political, most frequently remain latent for a variety of reasons.

Several interpretations of Giacometti's works are valid to varying degrees but they rarely encompass the sum total of their richness. The sculptor's wooden table-top structure *The Palace at 4 A.M.* (1932–33) is considered a masterpiece in sculpture of the Surrealist dream tableaux found in paintings. More baffling is his 1934–35 *Hands Holding the Void (Invisible Objects)*. Like his "Palace" but less objectified, the "primitivized" figure, whose face derives from a World War I gas mask, holds that which cannot be seen—the object and central contradiction of the Surrealist program: The invisible is the marvelous and it may be manifest anywhere in the world. In the following decade the quest to "truly see" will turn Giacometti's work in another direction and he will renounce these works as useless junk.

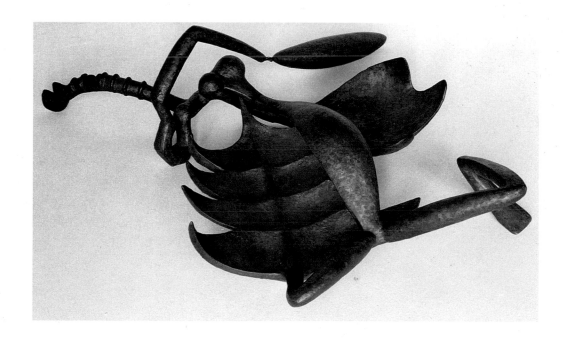

Woman with Her Throat Cut

ALBERTO GIACOMETTI; *1932; bronze (cast 1949); 8 x 34 x 25 in. (20.3 x 87.6 x 63. 5 cm). The Museum of Modern Art, New York.* Fully informed by Surrealist and Freudian theory, with a penchant for the Kafkaesque anthropomorphising of insects, Giacometti created a disturbing construction from his private fantasies of death and passion.

Sculpture and Objects

Sculpture developed late in Surrealism, likely because its solidity seems antithetical to their psychic experiments. It developed after the Second Manifesto in the 1930s as interest in automatism faded, in tandem with the rise of the illusionistic painting of Dalí, Magritte, and others. Although none of it can be called traditional sculpture, there did develop a new, important category of "objects."

With some, like Miró, sculptures appeared late in life as extensions of the fantastic biomorphs already created in painting. For others, like Arp, sculptural form was to be a by-product of the principles embedded in both nature and the artist's psyche. Max Ernst frequently developed a more

concrete subject matter that associates references to mythological or "ancient" presence and the psyche. His *The King Playing with the Queen* (1944) is a variation on a work whose central image, the horned king, emerged from automatist painting, much like Masson's iconography.

Perhaps the more important domain, one that became the predominant vehicle for the Surrealists, was the "Surrealist object." The Surrealist object is a three-dimensional collage of found objects chosen for their poetic meaning or psychic resonance rather than for aesthetic values. Dalí and Giacometti were the first to make what Dalí titled "Objects of Symbolic Function." In a sophisticated argument the Surrealists placed a primacy on real

Lobster Telephone

SALVADOR DALÍ; *1936; Surrealist object; 5¾ x 6 x 11¾ in.*
(15 x 17 x 30 cm). Tate Gallery, London.
Dalí was likely the first Surrealist to introduce objects
in the place of sculpture, but his intention was not,
as was Duchamp's, to challenge the meaning of art;
Dalí wanted Surrealist objects to function symbolically.

Poetic Object

JOAN MIRÓ; *1936; assemblage; 31⅞ x 11⅞ x 10¼ in. (81 x 30.1 x 26 cm).*
Gift of Mr. and Mrs. Pierre Matisse, The Museum of Modern Art, New York
The Surrealists brought a new category of object into existence,
alongside "sculpture." Their insistence on locating poetic moments
in the world demanded a serious sense of the "objective" world.
The dislocation through unreconcilable objects was the new surreality.

objects that maintain their integrity. Old art relied too much on the artist as manipulator of materials; Surrealism, like the analyst, was more "objective" in the discovery of the marvelous in the world. At the same time, in psychoanalytic terms of dream analysis, they recognized that objects, inclusive of body parts or Duchamp's ready-mades, by choice or chance, were repositories of personal desire made objective. Breton and others were inveterate flea-market habitués, since finding "things" of objectified desire, they believed, was akin to poetry.

Dali's 1936 *Lobster Telephone* is less poetic, more designed to startle through incommensurate objects in the same way that his paintings functioned. Breton's "poem-objects" and Joan Miró's "poetic objects" are closer to the visual complexity and multiple levels of association necessary to be poetic. Perhaps the best examples come from an American who was too reclusive to join the Surrealists but was greatly influenced by them. Joseph Cornell's little boxes of found objects, often with movable parts designed to make noise and including music boxes—such as the 1945 construction *The Hotel Eden*—are poetic recreations of moments, places, and meanings in his life. Meret Oppenheim's famous *Object*, a cup, saucer, and spoon covered in fur, invokes a primordial pun whose open reference to the sexual congress wittily applies in an everyday oral activity. The Surrealists made hundreds of such "objects" work on many levels.

A favored Surrealist object was that of the mannequin. These proliferated in the 1930s, '40s, and '50s, and appeared most famously in multiplication along a constructed "Street of Surrealism" for the 1938 international exhibition in Paris. The precise meaning of the mannequins varied. In early 1959 Meret Oppenheim attempted such a definition, apparently serving a banquet at her home and utilizing the body of a woman on a table as a food service tray. When Breton heard of this event he asked her to reproduce it at their 1959 International Exhibition on the theme "EROS," using mannequins of men and women.

The Hotel Eden

JOSEPH CORNELL; *1945; assemblage with music box; 15 x 15 ⅝ x 4¾ in. (38.1 x 39.7 x 12.1 cm). National Gallery of Canada, Ottawa.* One of the few American "Surrealists," Cornell never joined the movement despite his great admiration for them, and his immense gift for constructing poetic objects from collected debris and personal dreams.

Women and Surrealism

Dadaism and Surrealism both made promises that could not be fully kept regarding the role of women and the emerging feminist consciousness in the early twentieth century. Unrestricted freedom against control and domination was the dream of Surrealism and in the acceptance and celebration of the nature of instinct lay the supposed power to subvert repression.

The Surrealist celebration of love, of an open sexuality, mostly heterosexual, and the great weight they placed on the concept of "woman" helped advance the acceptance of women as independent and powerful creators. But accepting woman as an ideal rather than real construction (*la femme*)—muse, mystery, fantasy—along with the play of objectification of women and sexuality inherent in Freudian psychology, and, the culturally established sexism that men could not personally escape, all these worked as a reduction. However, the degrees of liberation and repression are relative to the viewer.

Meret Oppenheim accepted the "male-centeredness" of Surrealism as a standard historical attitude. To her liberated perspective, there was only full and equal acceptance of women in Surrealism. The female "muse," a role she played in front of

Man Ray's camera, could be seen simply as the male attempting to deal with the female side of his nature. In contrast, Léonor Fini, born in Buenos Aires and an international traveler and artist by her late teens, reportedly hated Breton's authoritarianism. Despite her many good friendships with the group and occasional exhibition she refused to join. Nor was the most famous woman "Surrealist," Frida Kahlo, a member. Despite being acclaimed by Breton, who stayed with Kahlo, her husband Diego Rivera, and Trotsky in Mexico in 1938, Kahlo rejected Surrealism as a Europeanized overlay. She was heir to Mexico's magic realism, an indigenous tradition, and there remained a divide between those of Spanish descent but European orientation, even within herself.

Tellingly, the photographic portraits of women Surrealists appear only in informal snapshots and are missing from the official group portraits. Yet more women exhibited with the Surrealists with more open

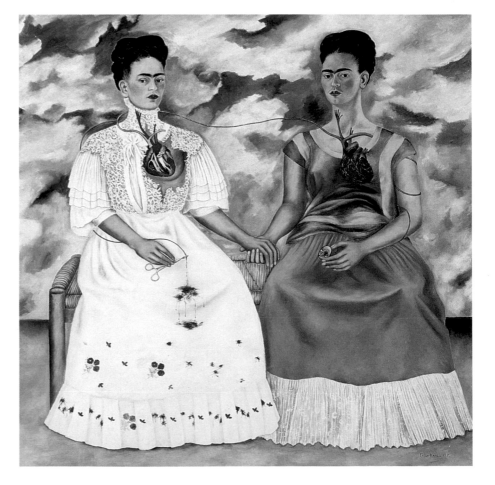

The Two Fridas

Frida Kahlo; *1939; oil on canvas;*

67 x 67 (170.5 x 170.5 cm).

Museo de Arte Moderno, Mexico City.

Kahlo's first big canvas was painted for the 1940s international Surrealist exhibition held in Mexico City, at the time of her divorce from Diego Rivera, represented by the bleeding heart. One Frida is Mexican, indigenous, and loved; the other is European, as is Surrealism, a movement whose members admired her work, but which she never joined.

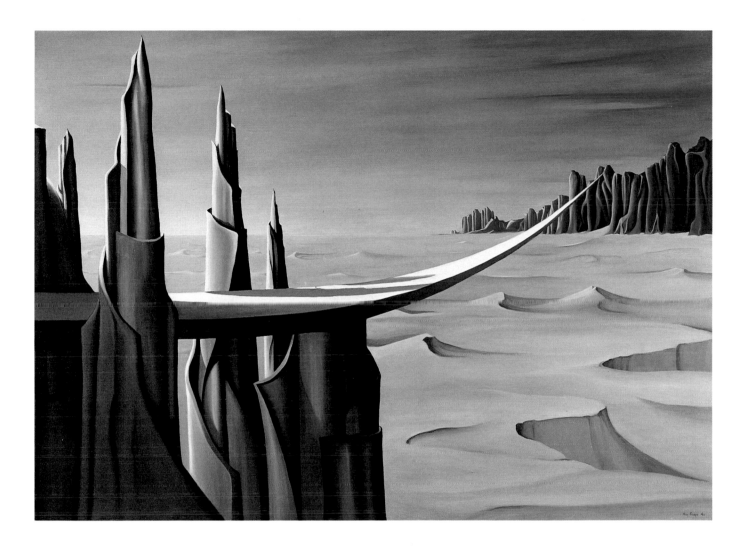

exchange between men and women as creators than in any other modern art movement.

In some cases, personal relationships were established between male and female Surrealists, but it was not the traditional causal relation of artistic influence as usually assumed. For instance, the American painter Kay Sage went on to marry Yves Tanguy in 1940 but had established a career with a one-woman exhibition years prior their meeting. It was an admiration for her work that drew the Surrealists to her, especially Tanguy and Ernst. Typically among Surrealists there was the affinity of shared aesthetics. Sage's cool, smooth-surfaced vistas, as in her *Danger, Construction Ahead* (1940), certainly paralleled Tanguy's work but speak to a quite different architectural and psychological world.

Leonora Carrington, an English painter and writer, met Max Ernst in 1937 and returned to Paris with him. By 1940 they were separated, and in 1942 she was living in Mexico, where she went on to make a life as a writer as well as painter. Carrington's atavism certainly related to Ernst's

Danger, Construction Ahead

KAY SAGE; *1940; oil on canvas; 44 x 62 in. (111.7 x 157.4 cm). Gift of Mrs. Hugh J. Chisholm, Jr., Yale University Art Gallery, New Haven, Connecticut.* Trained in the United States and Italy, Sage's first one-woman exhibition in 1936 was in Milan. In Paris from 1936 to 1939, she was hailed by the Surrealists. She was joined by Tanguy in the United States in 1940, where she executed this work. Sage's sparse expanse of isolated landscape gains tension from her sharp, architectural forms.

but her purposeful mixture of animal passion, alchemy, and the feminization of the creative spirit wove a magical ground at once powerful and unique in experience.

Dorothea Tanning, an American, met Ernst in New York and they married in 1946, the year they settled in Arizona. Her works share with Ernst a feel for de Chirico's space and a general air of strangeness filled with strong forces, but her imagery and her rather ferocious energy are the results of a serious exploration of no other but her own psyche.

Portrait of Père Ubu

DORA MAAR; *1936; gelatin-silver print;*
15⅝ x 11 in. (39.7 x 29.2 cm). Gilman
Paper Company Collection, New York.
In Alfred Jarry's play *Ubu Roi*,
Père Ubu was a comical/sinister
hero with a pointed skull and a
big nose and belly—a dictator
so self-centered and anarchistic
that all laws were contained in his
own belly. The Yugoslavian photo-
grapher Maar gives us the bestial
image of the beloved character.

Photography

It is often argued that the
introduction of photogra-
phy in the mid-nineteenth
century created a problem
for art, since painting now
had to find a new role out-
side representation. Sur-
realism, though, turned the
tables and problematized
photography by using its
very strength, its inherent
ability to create an image
we assume is factual and
objective, to its advantage.
Once a sense of the mys-
terious could be located
within and through pho-
tography, it was the perfect
medium for Surrealism
and no movement em-
ployed photography so extensively.

Man Ray's rayographs objectified or "found" another
dimension of the physical world, just as Atget's storefront
and doorway reflections documented entwined and shift-
ing perspectives. Dora Maar, a photographer best known
through her relationship with Picasso from 1935 to 1942,
was an independent member of the Surrealist movement.
Maar understood and objectified the dark humor, or
"umour," as Jacques Vaché called it, of the Surrealists.
Through her photograph of *Père Ubu* she gave a strange

but physical embodiment to the fictional character from
Alfred Jarry's play. Père Ubu's appetites proved too much
for himself and his country but he was a self-contained
anarchist beloved by the Surrealists in his bestial form.
The true animal nature of civilization was about to reveal
itself shortly in a more serious manner.

Under the influence of Man Ray, Raoul Ubac, a Belgian
artist, used photomontages, solarization, and "brulage," a
singeing of the negatives to melt them prior to printing.
In his *Battle of the Amazons*, the edges of the work physi-

cally erupt to become the images as they move in and out of a darkened matrix of war. It is a mythic battle which simultaneously maintains its mystery and a sense of the factual, since the year 1939 documents the eruption of World War II.

The insistence in Surrealism of locating the intersection of the real and the unreal had a major impact in documentary photography, practiced by such well known commercial photographers as Brassaï, who worked for *Harper's* in the 1930s, as did his colleague and sometime collaborator, André Kertesz; also involved was one of the most famous of World War II photographers, Lee Miller, who earlier had shot for *Vogue*. All three were intimates of the Surrealist circle; all three transferred what they learned, saw, and shot into variations of their commercial and artistic work. It is perhaps Miller, though, that Surrealism best served, if in an oblique manner. Her photographs were the first to record in full detail and make real to a disbelieving public the horrors of the Nazi genocide at Dachau and Buchenwald in 1944. As a realist, she documented the most bestial and "unreal" acts possible within the real world. The genuine madness of the world had outstripped and given lie to the dreams of the Surrealists.

Battle of the Amazons

RAOUL UBAC; *1938; solarized photomontage—gelatin-silver print; 13 x 17⅜ in. (33 x 44.1 cm). Courtesy of Jill Quasha.*

Coming first to Surrealist theory then to photography, this Belgian artist was able to develop techniques to match a vision expressed by Bataille as "living on the edge of limits where all understanding breaks down."

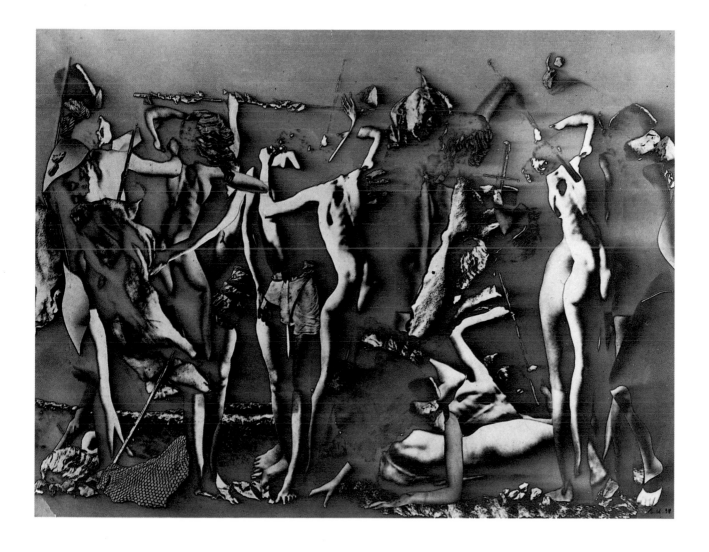

Postscript: Legacies

The legacy of Surrealism is massive and complex: It includes writing, poetry, painting, sculpture, found objects, performances, art, film, graphics, and graffiti. It developed ideas that influenced later movements as varied as Abstract Expressionism, Art Brut, Performance, Neo-Dada, Pop, and Conceptual art. The thinking of modern philosophers, from Walter Benjamin to Simone de Beauvoir and Jacques Derrida, as well as psychoanalysts like Jacques Lacan and Julia Kristeva, all came under the Surrealist spell.

Marcel Duchamp—who by 1920 had turned to machines and motion—coined the word most associated with the work of the American engineer-turned-artist, Alexander Calder. Duchamp christened the first 1932 exhibition of hand and motor driven abstract pieces "mobiles." The balanced forms were eventually engineered to move by the chance occurrence of wind, their biomorphic pieces derived from the basic pictorial vocabulary of artists such as Miró and Arp. Whether in small or large form, the shapes revealed a primordial level, marshaled into a suggested narrative—whether a lobster trap and fish, a child's toy, or some equally real monster of the unconscious mind. The gentle curves of Claes Oldenburg's soft Pop art sculptures from the 1960s and '70s evolved from a similar aesthetic in combination with Dadaist ideas.

One of the most important legacies of the Surrealist aesthetic was the abstract biomorph. As Dalí well knew, it could evoke nature and fear simultaneously. And in the

The Liver is the Cock's Comb

ARSHILE GORKY; *1944; oil on canvas; 72 x 98 in. (182.8 x 248.9 cm).*
Gift of Seymour H. Knox, 1956, Albright-Knox Gallery, Buffalo, New York.
Gorky was considered the bridge between the expatriated
Surrealists in the United States and the emerging American
Abstract Expressionists. Praised by Breton for his vision, history
has judged him more Surrealist than Abstract Expressionist.

right minds and hands it could do far more. The English sculptor Henry Moore combined Surrealist ideas and abstraction with his love of the figure and pre-Columbian art in a lifelong development. His organic abstract figures of women and children are meant to resonate with an earthiness that is both physical and psychological.

The French-born sculptor Louise Bourgeois was exposed to Surrealist theory early in her career. First attracted to abstract totemic shapes, similar in inspiration to those of Louise Nevelson, Bourgeois always incorporated an air of psychological disturbance in her work. Still master of the biomorphic form into the 1980s, she turned more consistently in the 1990s to explorations of the psyche through powerfully evocative installations. Her 1994 *Red Room (The Parents)* continues the poignant rememberances of psychological states and primal moments. She lays open the privacy of the psyche by reminding us of the psychological resonance we share through everyday materials, scenes, and moments. Ironically, she seems to provide a far more concrete formation of the dream than the Surrealists could manage largely by what is suggested rather than objectified.

Kenny Scharf, tagged as a member of the New York East Village punk-rock scene of the 1980s along with Keith Haring and Jean-Michel Basquiat, turned the Surrealist biomorph into "fun art." It is also a synthesis of sophisticated art world theory and comic-book culture appropriation that, since the 1960s, has reached into popular culture to challenge a number of assumptions about the nature and experience of art.

The initial legacy of the Surrealists in the United States, however, came during their expatriated status during World War II, where they published articles, exhibited, and provided ideas. At the time when the Abstract Expressionists were searching for new ways to express their passions, Surrealist concerns for primitive mythology derived from the unconscious pointed the way for painters such as Mark Rothko, Barnett Newman, Jackson Pollock, Arshile Gorky, and others. Pollock's all-over compositions after 1947 are unthinkable without the Surrealist impetus behind automatism. Interestingly, Allan Kaprow, the founder of the spontaneous art events known as "Happenings," cited his shaping influence as the automatic and liberating gestures of Pollock. Breton called Gorky's 1944 *The Liver is the Cock's Comb* "mar-

velously unpremeditated" and "the great gateway open on to the analogical world."

Simultaneously in Europe—the 1940s and '50s—Surrealism provided England's Francis Bacon with the basis for one of the most disturbing uses of biomorphic imagery. His *Three Studies for Figures at the Base of a Crucifixion*, exhibited in the painter's first exhibition in over a decade in 1945, gave full voice to human horror and repression. The same impulse developed in another direction drove the influential theories of Jean Dubuffet's Art Brut or "raw art." His love, and famous collection, of the art of untrained individuals, his repudiation of cultural values, and his reliance on the unconscious and the primitive derived in part from his friendships among the Surrealists. Dubuffet developed a handling of materials that paralleled World War II's destruction in Europe.

Yet another generation in America owed a less direct debt to the Surrealists. Robert Rauschenberg, who, with his colleague Jasper Johns, was seen in opposition to Abstract Expressionism and most associated with a new Dadaism, had been influenced directly by the tradition of the Surrealist object. Breton recognized the challenge they posed and asked both artists to exhibit with the Surrealists.

Building on these new and old traditions, the 1960s "junk" and "assemblage" artists reached back via Surrealism to the found object of Duchamp and Picasso. On occasion, with artists like Lee Bontecou, one also finds the echo of their powerful psychological concerns. In a series of untitled assemblages in the 1960s Bontecou turned the Freudian tables with an obsessive image of a face-vagina transposition, whose frightening zipper teeth held out the countervailing promise and independence of the feminist movement.

Three Studies for Figures at the Base of a Crucifixion

FRANCIS BACON; *c. 1944; oil on board, one of three studies; 37 x 29 in. (93.9 x 72.6 cm). Tate Gallery, London.*
Bacon, an English painter, was one of the few older European artists admired by the emerging postwar generation because he seemed to register the horror of the war in a fundamental form of terror. The biomorph is Surrealist, the psyche his own.

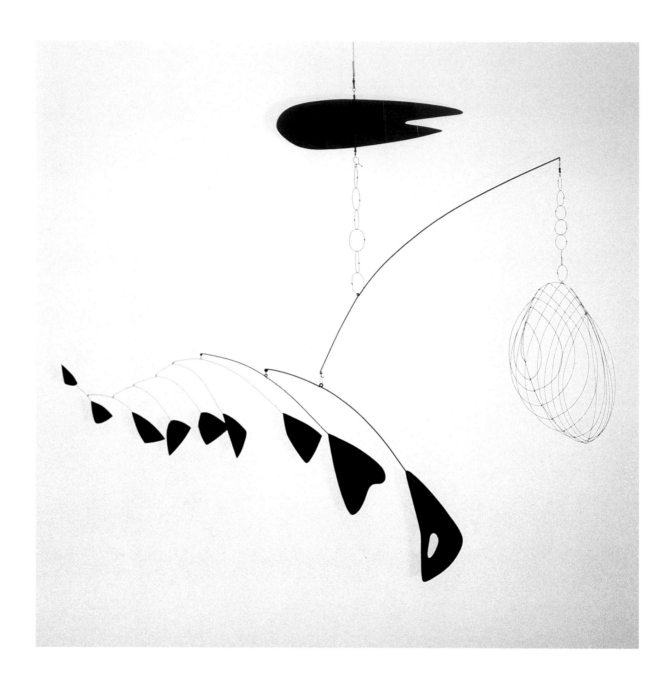

Lobster Trap and Fish Tail

ALEXANDER CALDER; *1939; mobile: painted steel wire and sheet aluminum;*

8 ft. 6 in. x 9 ft. 6 in. (260 x 290 cm).

Commissioned by the Advisory Committee for the stairwell of the museum,

The Museum of Modern Art, New York.

Calder combined the Surrealists' organic biomorphs
with his engineering background to construct
much-admired fantasies that moved in the air by chance.

Reclining Figure

HENRY MOORE; *1939; elm wood; 37 in. x 6 ft. 7 in. x 30 in. (93.9 cm x 2 m x 76.2 cm).*
Gift of the Dexter M. Ferry, Jr. Trustee Corporation, The Detroit Institute of Arts.
Moore, like several English sculptors, reconciled the biomorphic
form with abstraction to form a psychological resonance between
the figure and nature that he much admired in primitive art.

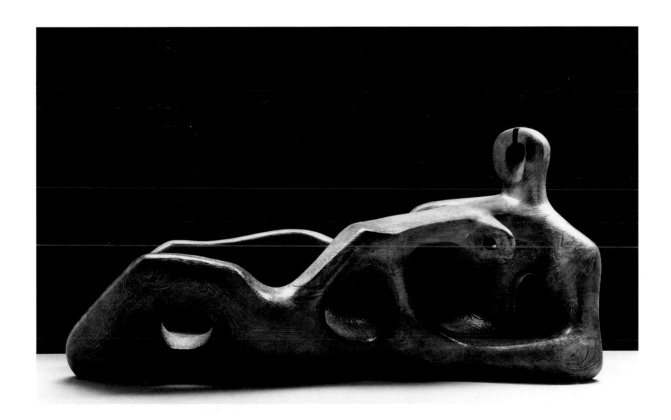

Crucifixion

PABLO PICASSO; *1930; oil on wood;*
19¾ x 25⅞ in. (50 x 65.5 cm).
Musée Picasso, Paris.
In the late 1920s Picasso,
long accepted by the
Surrealists on his own,
Cubist terms, began to
incorporate both the
curvilinear biomorphic
form and a more tor-
tured psychological tone
in many of his works.

The Horde

MAX ERNST; *1927; oil on canvas; 44⅞ x 57 in.*
(113.9 x 146 cm). Stedelijk Museum, Amsterdam.
Part of a series of paintings whose images
derived from rubbings (*frottage*), the horde
was a group of monsters that have been
interpreted as demons of the "dream-reality"
in which Ernst lived and as part of his devel-
oping critique of the forces of civilization.

The Palace at 4 A.M.

ALBERTO GIACOMETTI; *1932–33;*
construction in wood, glass, wire, and string;
25 x 28¼ x 15¾ in. (63.5 x 71.8 x 40 cm).
The Museum of Modern Art, New York.
This work, in which the vision of
the prehistoric bird takes wing at
4 A.M., has long been considered
the classic sculptural statement of
the Surrealist dream image or space.

Bed

ROBERT RAUSCHENBERG;
*1955; combine painting: oil
and pencil on pillow, quilt,
and sheet, on wood supports;
6 ft.¹/₄ in. x 31 x 8 in.
(191.1 x 80 x 20.3 cm). Gift of
Leo Castelli in honor of Alfred
H. Barr, Jr., The Museum
of Modern Art, New York.*
Rauschenberg's *Bed*
was exhibited at the
Paris "Exposition
Internationale du
Surrealism" in the
winter of 1959–60, next
to Giacometti's *Invisible
Object*. Ultimately
disparate in vision, the
Surrealists nonetheless
valued his disjunctions
as reliant on their devel-
opment of the object.

Illumined Pleasures

SALVADOR DALÍ; *1929; oil and collage on hardboard; 9 x 13 in. (23.8 x 34.7 cm).*

The Sidney and Harriet Janis Collection, The Museum of Modern Art, New York.

The exact nature of the psychic scene of Dalí's pleasures remains enigmatic, but ranges among
masturbation, castration, and the primal scene. Dalí is present as the profile face and the standing
youth, as is his father, the bearded man; the identity of the woman with the bloody knife is unknown.

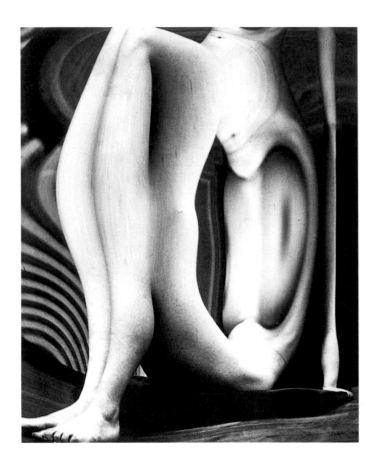

Distortion #48

ANDRÉ KERTÉSZ; *1933; gelatin-silver print; 9 x 7²¹/₃₂ in. (24.1 x 19.4 cm). J. Paul Getty Museum, Malibu, California.* Kertész was always interested in mirrors and distortions, but did not begin his distortion series until 1933, when a Paris amusement-park mirror inspired two hundred negatives in four weeks. His altered vision influenced commercial photography into the 1960s.

Danger on the Stairs

PIERRE ROY; *1927 or 1928; oil on canvas; 36 x 23⅝ in. (91.4 x 60 cm). Gift of Abby Aldrich Rockefeller, The Museum of Modern Art, New York.* Roy's painting, whose style was dubbed "Magic Realism," showed in the first Surrealist exhibition in Paris in 1925. In the 1920s he was one of the few Surrealists painting in a realistic style. Eventually the possibilities of illusionism attracted others.

Painting

JOAN MIRÓ; *1933; oil on canvas; 68 x 78¼ in. (174 x 196.2 cm).*

Loula D. Lasker bequest (by exchange), The Museum of Modern Art, New York.

Although this series of paintings is an excellent example of
Miró's development into abstraction, it is the hidden process of
transformation from object to abstraction that is the important issue.

Woman-Amphora

Brassaï (Gyula Halász); *1935; gelatin-silver print; 15 7/16 x 11⅝ in.*
(39.2 x 29.5 cm). J. Paul Getty Museum, Malibu, California.

Transformation combines with biomorphic eroticism as an exercise
in the Surrealist concern for shifts in meaning. Brassaï met the Surrealists
at the time he began shooting for *Harper's*, but his concentration on
the objective quality of his images stopped him from joining them.

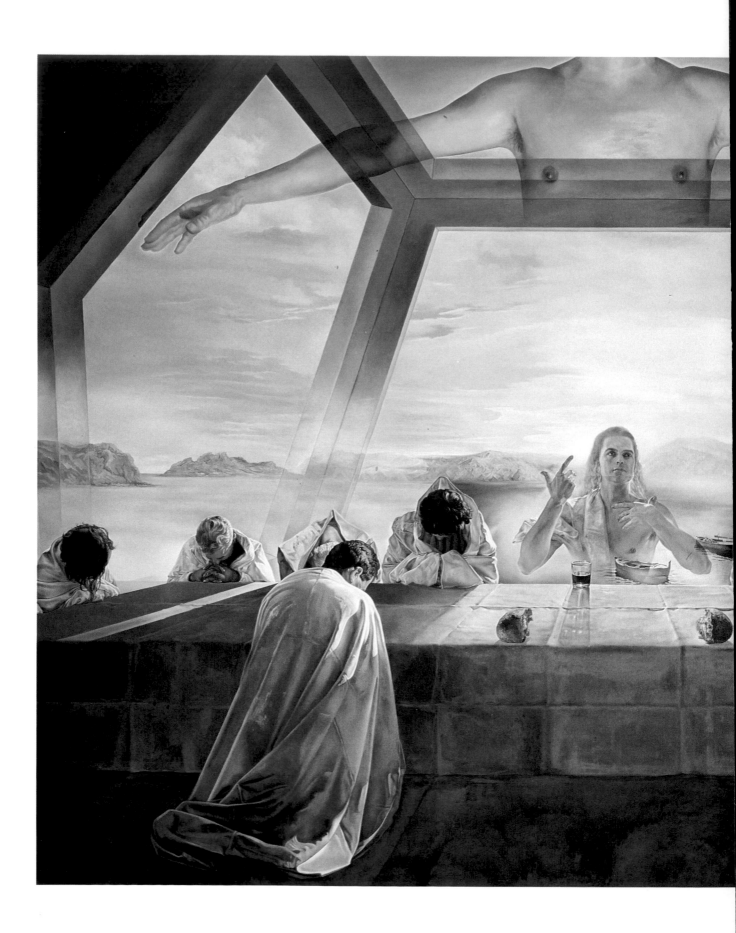

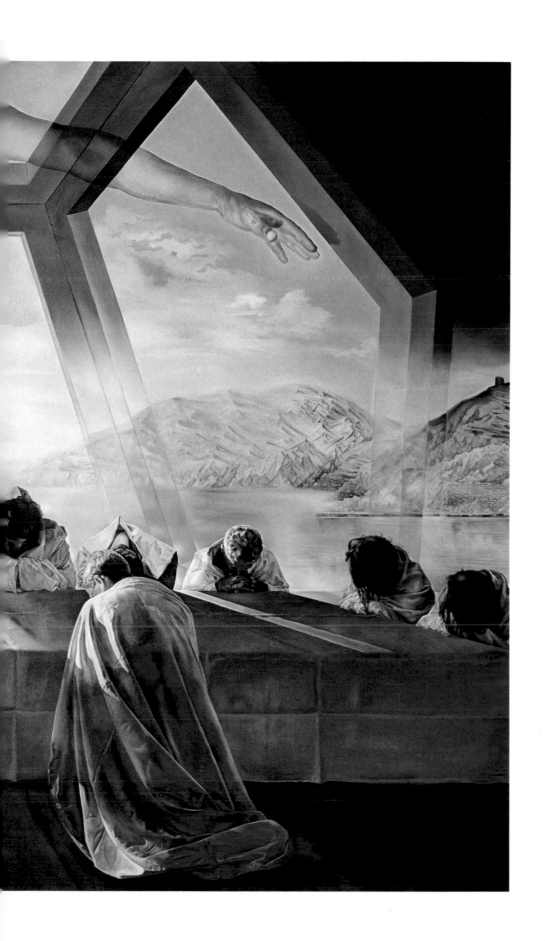

The Sacrament of the Last Supper

SALVADOR DALÍ; *1955;*
oil on canvas; 65⅛ x 104 in.
(167 x 268 cm). The National
Gallery of Art, Washington, D.C.
Dalí turned to Catholicism,
and after 1950 placed his
Surrealist techniques in the
service of reinvigorating
Christian religious art with a
sense of mystery and revelation.

Doll

HANS BELLMER; *1937;*

pen and tempera on black paper;

12 x 10 in. (30.4 x 25.2 cm).

The Joan and Lester Avnet

Collection, The Museum

of Modern Art, New York.

This drawing, which combines abstract biomorphic body parts along with references to the mechanical and insect appendages, makes the case more for social awareness than for eroticism. Not all of Bellmer's works can make such claims, nor are his works uniformly interpreted.

Doll

HANS BELLMER; *1935–36;*
painted aluminum (cast 1965);
19⅛ x 10⅝ x 14⅞ in.
(48.5 x 26.9 x 37.6 cm). The Sidney
and Harriet Janis Collection, The
Museum of Modern Art, New York.
The German Expressionist
Hans Bellmer made contact
with both the Surrealists and
a doll-maker in the 1920s.
Inspired by a play which fea-
tured an automated doll, he
and his wife constructed their
first *poupée* ("doll"). Despite
the supposed sadism of his
work, his emphasis was on
the issue of construction to
parallel social constructions.

Spring Banquet

MÉRET OPPENHEIM; *1959; photograph. Méret Oppenheim Photo Archive, Bern.*

A rare archival photograph documents Oppenheim's use of
the female body as a serving tray for food in a private banquet.

Object

MÉRET OPPENHEIM; *1936; fur-covered cup, 4⅜ in. (10.9 cm.) diameter;*

saucer, 9⅜ in. (23.7 cm.) diameter; spoon, 8 in. (20.2 cm.) long;

overall height 2⅞ in. (7.3 cm). The Museum of Modern Art, New York.

One of the sensations of both the Paris and New York Surrealist

exhibitions in 1936, this intimate object was fashioned from its everyday

function to fuse sexuality, humor, and scandal; the perfect Surrealist object.

There is No Finished World

ANDRÉ MASSON; *1942; oil on canvas;*
53 x 68 in. (134.6 x 172.7 cm). Bequest of
Saidie A. May, Baltimore Museum of Art.
Masson, along with many of
the Surrealists, took up residence
in the United States during
World War II. His quest for
a new mythology of older
forces exerted a powerful
influence on the emerging work
of the Abstract Expressionists.

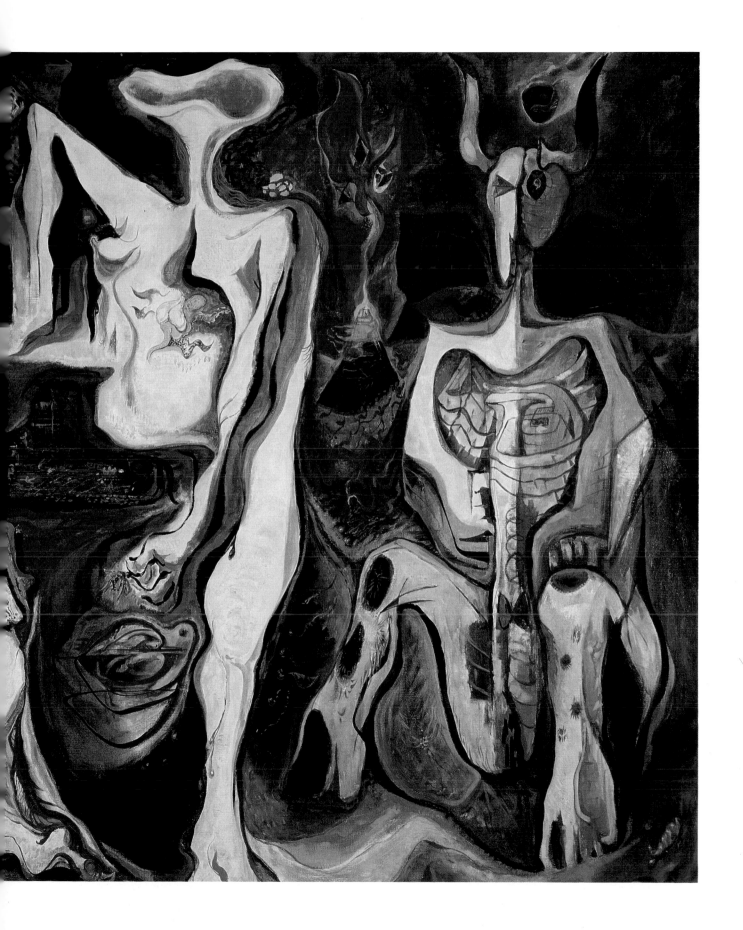

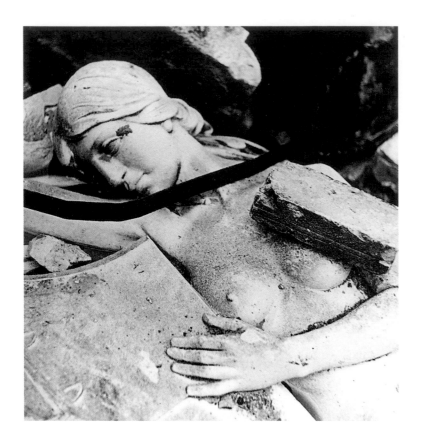

Revenge on Culture

LEE MILLER; *1940; from her book* Grim Glory; *gelatin-silver print;*
16 x 12 in. (40.6 x 30.4 cm). Lee Miller Archives, East Sussex, England.
The vision the American photographer Lee Miller
developed during Surrealism prepared her to see
the grim consequences of WW II, whether documenting
the concentration camps or recognizing the poignant
power in such a juxtaposition as the one shown here.

The Jungle

WIFREDO LAM; *1943; gouache on paper mounted*
on canvas; 7 ft. 10¼ in. x 7 ft. 6 in. (239.4 x 229.9 cm).
Inter-American Fund, The Museum of Modern Art, New York.
Born in Cuba, trained in Spain, Lam met
Picasso in 1938 and, later, the Surrealists.
He combined the influences from his
mixed heritage—such as African masks
and voodoo figures—with biomorphic body
parts and personal fantasy in what is only
now being recognized as an authentic synthesis.

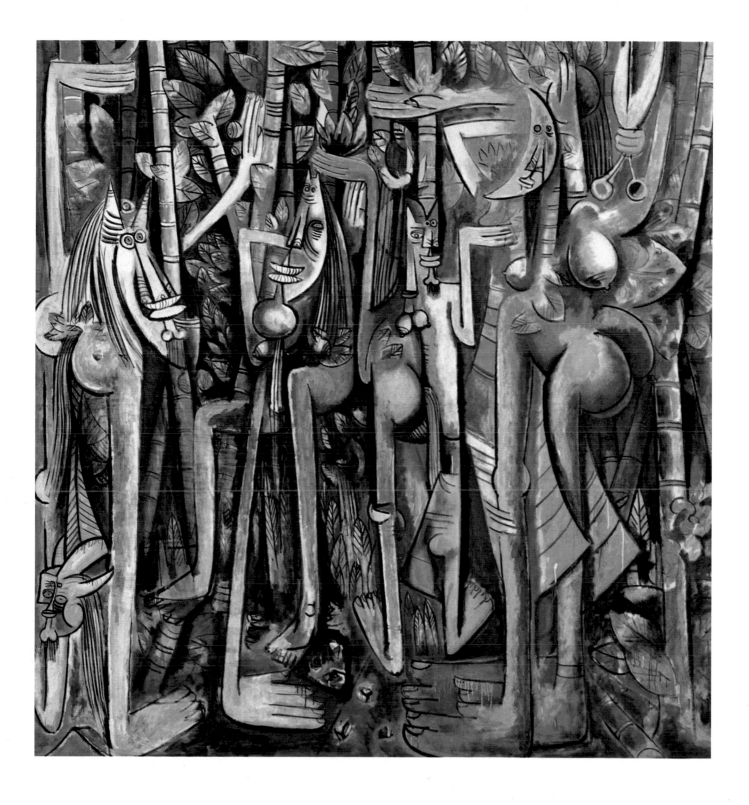

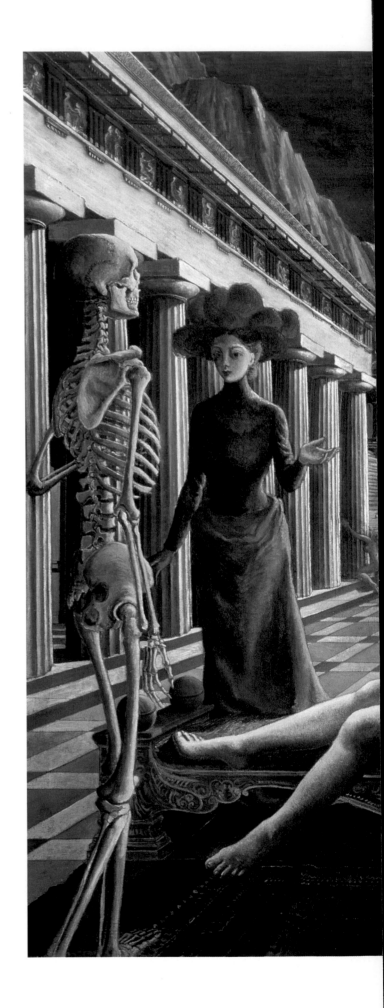

The Sleeping Venus

PAUL DELVAUX; *1944; oil on canvas. Tate Gallery, London.*
Delvaux was not a formal member of the
Surrealist movement, but developed the illu-
sionist dream space of Dalí and Magritte in
unique ways. The immobility of his scenes is
that of dream time; while woman symbolizes
both the erotic and the unattainable, all is
suspended, including time, death, and viewer.

The Childhood of Oedipus

KURT SELIGMANN; *1944; etching; 17¾ x 11¾ in. (45 x 29.8 cm).*

Prints Collection, Miriam and Ira D. Wallach Division of Art, Prints and

Photography, Astor, Lenox and Tilden Foundation, The New York Public Library.

This Swiss painter produced a number of prints in which
spiky forms join with the Expressionist roots of the imagery
to transform a formal tension into a psychological one.
The use of the Oedipus myth derives from Freud, and impelled
the interests of many American artists during the war.

Triumph and Glory
(Corps de Dame)

JEAN DUBUFFET; *1950; oil on canvas; 51 x 38 in. (129.5 x 97.7 cm).*

The Solomon R. Guggenheim Museum, New York.

Like Bacon, Dubuffet was also much admired for recording the
shock of the war through the raw material surfaces and primitive
markings he shaped into a philosophy of art called "Art Brut."

Les Demoiselles de la Nuit

LÉONOR FINI; *1948; gouache on paper; costume design for Margot Fonteyn. CFM Gallery, New York.*

In the late 1930s, many of the Surrealists turned to design and attempted to integrate their visions into a more public domain. Here the Argentine-born Fini merges the practicality of ballet costumes with her interest in a realm between human and bestial.

A Mi-Voix

DOROTHEA TANNING; *1958; oil on canvas; 51¼ x 38¼ in. (130.1 x 97.1 cm). Tate Gallery, London.*

Tanning's figures give simultaneous voice to two domains as they fluctuate between the figures of the visible world and another world of psychic forces, illustrated with wind, light, and vortex.

Prescience

MATTA (ROBERTO ANTONIO SEBASTIAN ECHAUREN); *1939; oil on canvas; 36 x 52 in. (91.4 x 133 cm). The Ella Gallup Sumner and Mary Catlin Sumner Collection Fund, Wadsworth Atheneum, Hartford, Connecticut.* The Chilean-born artist was active in Paris Surrealism in the 1930s and in the United States during World War II, where his lyrical abstractions influenced American painters like Gorky. The dreamscapes are intended as fields of metamorphosis where we discover a "prescient" language of shapes.

121

Red Room (The Parents)

LOUISE BOURGEOIS; *1994; mixed media; 96²/₃ x 166¹/₃ x 94 in. (247.7 x 426.7 x 242. 2 cm).*

Photograph by Peter Bellamy; collection of the artist, Robert Miller Gallery, New York.

Well versed in Surrealist theory, Bourgeois has always dealt with a sense of psychic disturbance no matter what her media or form. In recent years, she has moved away from blatant sexuality to a calmer but ultimately more disturbing psychodrama.

The Promenades of Euclid

RENÉ MAGRITTE; *1955; oil on canvas; 63 x 51 in.*
(162.8 x 130.8 cm). The William Hood Dunwoody
Fund, The Minneapolis Institute of Art.
The illusionism of painting had become,
over time, a stand-in for reality; this
logic intrigued Magritte sufficiently to
consistently re-pose the question of the
relationships between image and reality.

Untitled

LEE BONTECOU; *1961; welded steel with canvas; 72⅝ x 66 x 25⁷/₁₆ in.*
(184.5 x 167.6 x 64.6 cm). Whitney Museum of American Art, New York.
Usually placed with the 1960s' assemblage artists who
espoused what is known as a "junk" esthetic, Bontecou's
works move well beyond the formalist exercises of disjunction
for its own sake to embody a powerful psychological vision.

When the Worlds Collide

KENNY SCHARF; *1984;*
oil, acrylic, and enamel
paints on canvas;
10 ft. 2 in. x 17 ft. 5¼ in.
(309.8 x 531.4 cm).
Whitney Museum of
American Art, New York.
Part of the informal,
storefront gallery world
and hip-hop club culture
of the 1980s, Scharf
combines the biomorph
with electric colors and
comic-like imagery to
create a "street" version of
a user-friendly Surrealism.

INDEX